DIGITAL PHOTOGRAPHY EXPERT

Light

AND

Lighting

DIGITAL PHOTOGRAPHY EXPERT

Light
AND
Lighting

MICHAEL FREEMAN

LARK BOOKS

A Division of Sterling Publishing Co., Inc.
New York

Digital Photography Expert: Light & Lighting
10 9 8 7 6 5 4 3 2 1

Published by Lark Books, a division of
Sterling Publishing Co., Inc.
387 Park Avenue South, New York, N.Y. 10016

Text © The Ilex Press Limited 2004
Images © Michael Freeman

This book was conceived, designed,
and produced by:
The Ilex Press Limited,
Cambridge,
England

Distributed in Canada by Sterling Publishing,
c/o Canadian Manda Group,
One Atlantic Ave., Suite 105
Toronto, Ontario, Canada M6K 3E7
All rights reserved

Library of Congress Cataloging-in-Publication Data
Freeman, Michael, 1945-
Digital photography expert: light & lighting/Michael Freeman.–1st ed.
 p. cm.
 ISBN 1-57990-526-9 (pbk.)
 1. Photography–Lighting. 2. Photography–Digital techniques.
 I.Title.

TR590.F723 2003
778.7'2–dc21

2003007920

If you have questions or comments about this book, please contact:
Lark Books
67 Broadway
Asheville, NC 28801
(828) 253-0467

Printed in China

Contents

Introduction

Light is the essential commodity in photography. It creates the image, and at the same time is responsible for much of the style and feel of a picture. Making sure that just the right quantity passes through the lens and the shutter is the job of the camera's exposure system, whatever the means of recording the light. This has always been so, from the days of daguerreotypes through glass plates to flexible film, and now to the sensor array that is at the heart of a digital camera.

Do digital cameras make a difference to this special relationship between photography and light? Substantially so, and for two reasons. First, the sensor array has the ability to react more adaptively to light than can a film emulsion. Second, and more important, the light information captured is then processed by the camera and later, if you like, on a computer. All of this makes it possible to capture the subtle effects of light and color as you see them—and also as you would like them to appear. Indeed, digital photography provides more control over the light recorded than could ever be dreamed of in the days of film, and making full use of the camera's capabilities opens up a new world of precision and choice.

At the same time, it's important not to get carried away with the technical marvels of digital capture, impressive though they are. How you use the light is a matter for your eye as a photographer, and this is ultimately what photography is all about—the personal view and the individual imagination. The way in which light strikes a landscape or a surface has an important bearing on the detail and texture that your photograph will show, while the quality of the light can often determine whether the image is attractive, striking, gentle, or dramatic.

Ultimately, interesting and successful use of light depends on your ability to judge and feel its character. Although it is easy enough to describe the detailed appearances—such as how the angle at which light strikes a subject shows a certain level of texture, or how atmospheric haze changes the color—there are more subtle, underlying effects at work. These may not lend themselves so readily to description, but they can make or break a picture.

The Facts of **Light**

Digital capture brings an unprecedented exactness to measuring light. The more advanced cameras, for instance, will display a histogram of any image—basically a graph of how the various tones in an image, from dark to light, are distributed. Once the image has been transferred from the camera to the computer, this and other kinds of analysis can be made. These are not academic exercises, but are practical means of capturing and displaying the fullest visual information—making the best of light and color.

The process of digital photography begins at the level of each miniature photocell on the sensor array in the camera. Light falling on it is recorded as an electrical charge, in proportion to the light's intensity. The pattern of millions of these units ultimately becomes the image. To make sure that this reads well, the camera and lens have to control the quantity of light, its color balance, and (in the case of flash) its synchronization. Quantity means, in practice, exposure, as the sensor needs a certain amount of light in order to make a legible image. There is some leeway in this, because the sensitivity can be adjusted to dim lighting conditions, albeit with some loss of quality. Gone are the days of choosing types of film—the entire range is now effectively embedded in one sensor array.

This is one variable in dealing with the amount of light. The other two are the shutter and the aperture, which each regulate the amount of light. They have other functions as well, and in many picture situations you can choose which has the higher priority—a higher shutter speed to freeze movement or a smaller aperture to give better depth of field. Unless you decide to override the controls, most cameras now adjust shutter and aperture automatically, so you can usually assume that the exposure will be acceptable.

Light also has color, more so than the human eye normally recognizes. We accommodate so well to the color of light—whether white from a midday sun, blue in the shade, orange by incandescent lamps, or greenish under fluorescent tubes—that it all tends to looks normal. The camera is more faithful to the original source, and compromises less, which, in the days of film, caused some unpleasant surprises in the form of strong and unwanted color casts to photographs. Digital capture takes care of this in two ways: by showing the result immediately, and by being able to make adjustments within the camera.

Modern digital cameras take care of most of these technical matters, which is all to the good because it is in the quality of light that the really important decisions lie. This means appreciating what kind of lighting works most effectively for different subjects and scenes; how to make the best use of the lighting conditions that you are faced with when you cannot change them; and being sensitive to the varieties of mood that different types of lighting can create.

The spectrum

Light is the visible part of a much larger spectrum of radiation: it is just what we can see; no more and no less.

Light is radiation. Specifically, it is radiation that the human eye can see, but it is only one small band in the entire electromagnetic spectrum. This spectrum consists of a range of wavelengths, from short to long, which includes, in addition to light, gamma radiation, X rays, radar, radio, and other forms. There are no divisions between these groups, and no breaks in the spectrum; instead, there is a steady, continuous progression of wavelengths.

Wavelength marks the difference between all these types of radiation. Gamma rays, at the short end of the spectrum, have wavelengths of only $1/100,000,000m\mu$. Radio waves, by contrast, can have wavelengths of up to 6 miles (10km). Between these extremes, the human eye is sensitive to a narrow band of wavelengths of between 400 and 700 nanometers (nm) or millimicrons (10^{-9} meter or $1/1,000,000m\mu$).

A rainbow's spectral colors
One of the most common naturally occurring versions of the spectrum is the rainbow. Raindrops act as miniature prisms, refracting "white" sunlight into its component colors. Weak rainbows usually lack one end of the scale (red or violet).

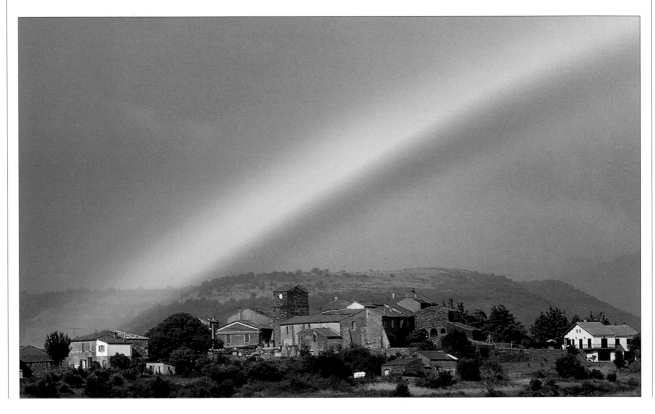

Just as most variations in wavelength produce radiation that has very distinctive properties, the small range of visible wavelengths contains a variety of effects. The eye sees these small differences as different colors. We perceive the shortest visible wavelengths as violet, and the longest as red. In between are the familiar colors of the spectrum, of which the eye can normally distinguish seven definite hues. These colors "exist" only in our eye and mind; the light waves themselves are not colored. Also, unlike other senses, human vision is not capable of identifying the component parts of light. We can distinguish the different flavors that make up a particular taste, and the sounds of different instruments in an orchestra, but the best we can do with light is to see the mixture of wavelengths as one color. We perceive all of them mixed together as white. White is our reference point for color. The "neutrality" of white occurs because our eyes evolved under it—the color of the midday sun.

What we call "color" is, in fact, made up of different qualities. The terms hue, saturation, and brightness (HSB) are used to describe the way that we see color. Hue is what distinguishes red from green and green from yellow—the wavelength. Saturation (which is also sometimes known as chroma) is the purity of that hue. Brightness is self-explanatory.

The eye's sensitivity

The human eye is not equally sensitive to all the wavelengths; it peaks in the middle, at around yellow-green. The graph below, colored for the way we perceive the different wavelengths, shows the visual luminosity curve for the eye. Crudely put, this means we see better by green light than by red.

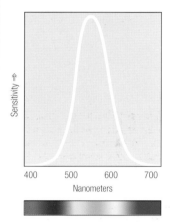

The electromagnetic spectrum

The visible spectrum of wavelengths forms only a small part of the entire range of electromagnetic wavelengths—the part from 400nm to 700nm (between infrared and ultraviolet). X rays and gamma rays, being much shorter, are more energetic and can pass through many solid materials. The longer radio waves have too little energy to be perceived by the human body.

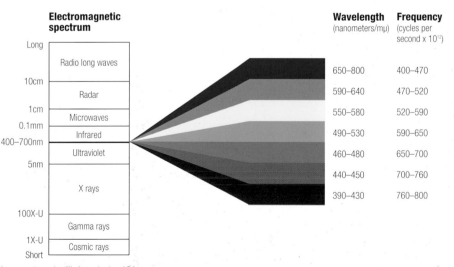

Electromagnetic spectrum

Long	
	Radio long waves
10cm	
	Radar
1cm	
	Microwaves
0.1mm	
400–700nm	Infrared
	Ultraviolet
5nm	
	X rays
100X-U	
	Gamma rays
1X-U	
Short	Cosmic rays

Wavelength (nanometers/mμ)	Frequency (cycles per second x 10¹²)
650–800	400–470
590–640	470–520
550–580	520–590
490–530	590–650
460–480	650–700
440–450	700–760
390–430	760–800

1 nanometer = 1 millimicron (mμ) = 10^{-9}m

Brightness

If there is an average source of light in photography, it is normal daylight; the scale of shutter speeds and aperture settings, as well as the camera's basic sensitivity, are geared to this.

Most digital cameras' high-quality setting is ISO 100 or 200, and a normal exposure in the middle of a clear day would be about f16 at 1/125 or 1/250 second. Compared with this daylight standard, most artificial light sources are weak. Certainly, non-photographic light, such as domestic lamps and street lighting, causes some problems for photography. Even photographic lighting causes more difficulties because the light levels that they offer are too low rather than giving too much output. At close distances, such as in still-life photography, this problem is rarely severe, but large-scale sets usually need expensive amounts of equipment to throw an adequate amount of light on them.

Light intensity depends on three things: the output of the source; how it is modified; and its distance from the subject. The sun is our main source of light, but there are a number of other, artificial light sources that can be used for photography, albeit with varying degrees of success. Some, like domestic tungsten lamps, exist simply because they are an easy method of producing light, even if this bears little resemblance to daylight. Others, like fluorescent lamps, are designed to imitate the effect of daylight on a small scale. Still others, such as electronic flash, are intended only to meet the specific needs of photography.

There are three main light sources other than daylight: incandescent light; fluorescent and vapor lamps; and electronic flash. Incandescent light works by means of intense heat. In a tungsten lamp, the most common type of incandescent light, a tungsten filament is heated electrically, and

Sunlight
As well as being the most common light source in photography, sunlight is also the brightest in normal circumstances. Shooting directly into the sun creates images with a range of brightness too great for any film or sensor to record fully.

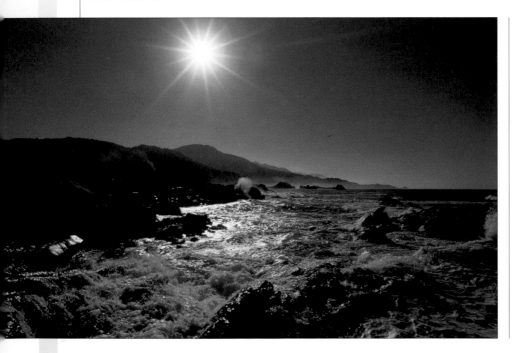

glows. Fluorescent and vapor lamps produce light by exciting the molecules of a gas, again with an electric current. An electronic flash unit uses the principle of an electronic discharge, but this occurs as a single, very short pulse in a sealed gas-filled tube.

The sun is so far away that its light is just as intense in one part of a scene as in any other. That is, the difference in distance between the horizon and foreground in a landscape shot is infinitesimal compared with the distance between the sun and the earth. All artificial light, however, weakens with distance, and the falloff in illumination is a major consideration with photographic lighting and available lighting at night.

Daylight and tungsten lamps are continuous and, at least from the point of view of exposing a photograph, steady. Fluorescent lamps, on the other hand, pulsate, producing rapid fluctuations in their light output. Flash tubes are built on the principle of a pulse: one single, continuous, concentrated discharge that will expose a photograph just as well as a lower level of continuous light. Synchronizing the flash pulse to the time that the camera shutter is open is critical for regulating the exposure of a photograph.

Domestic tungsten

After daylight, the most common lighting condition is that found in buildings. The intensity of the light depends on the size of the room and the position of the windows and lamps, but even during the day, light levels are likely to be in the order of 7 stops lower than outdoors.

Flame

The weakest light source normally encountered in photography is probably a candle. Although the flame is always bright enough to record an image, the illumination from the flame needs long exposures.

Inverse square law

Light falls off with the square of distance—twice as far from a light source means four times less illumination. The most noticeable thing about this comparison chart of the main light source used in photography is that the sun's light does not seem to change with distance. This is because the distance between the earth and the sun is so much greater than any local differences.

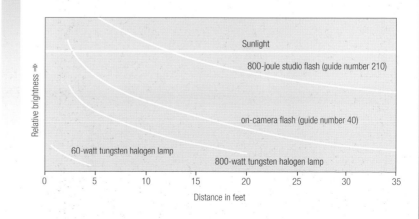

Relative brightness ⇑

Sunlight

800-joule studio flash (guide number 210)

on-camera flash (guide number 40)

60-watt tungsten halogen lamp

800-watt tungsten halogen lamp

0 5 10 15 20 25 30 35

Distance in feet

The camera's sensor

The single chip that replaces film in a digital camera is an array of some millions of closely packed photosensor cells. This is the key component in creating the image, and in adjusting it.

Sensor arrays are either CCDs (charge-coupled devices) or CMOS (complementary metal oxide semi-conductor). Both types of sensor work on the same principle. Each photosensor on the array is responsible for capturing one unit of information for the final image—in other words, one pixel. ("Pixel" is a contraction of the term "picture element.") Pixels can be thought of as the equivalent of grain in film photography. This is not

Color Filter Array (CFA)

The photodiodes used in a CCD are actually monochrome devices, incapable of distinguishing between different wavelengths of light. In order to capture color information, the CCD is covered by a CFA (Color Filter Array), which ensures that each photodiode receives light of only one color wavelength. As only one-third of the true color information is actually recorded per pixel, the other two-thirds needs to be interpolated from the information received by the surrounding photodiodes. In order to capture colors in the a way that looks natural to the human eye, most CFAs do not contain equal numbers of red, green, and blue filters. In the standard Bayer Pattern array used in many digital cameras, there are many more green filters in operation, due to the eye's greater sensitivity to this color.

CCD and CMOS

There are two competing technologies for sensor arrays, although both are constructed and work in much the same way. CCD (charge-coupled device) is the original and still the most common, with a photodiode at each pixel site; extra circuitry is needed to amplify and convert the signal. The newer CMOS (complementary metal oxide semi-conductor) adds amplifiers and selection circuitry to each photodiode; needs less power to operate; and can be made more cheaply. Its disadvantage is that the extra circuitry at each pixel site reduces the area for gathering light, and so needs other solutions for boosting the sensitivity.

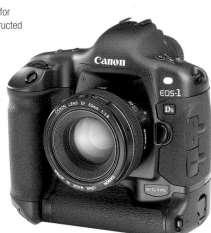

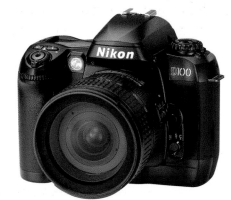

Canon's EOS-1DS uses an 11 megapixel, full-frame 35mm CMOS sensor with associated circuitry to create images of superb color and clarity. Nikon's D100 uses a more conventional 6 megapixel, 28.4mm CCD.

Keeping the sensor clean

Unlike film, which moves across the back of the camera between exposures, the sensor array stays put—and there is only one. This means it is essential to keep the sensor array absolutely clean: one speck of dust will appear on all the images, and even though this can be retouched digitally later, it can be a serious nuisance. Fixed-lens cameras are effectively sealed, but SLRs are more susceptible to foreign matter entering and settling on the sensor. Take the following precautions (much more seriously than you would with film):-

☐ Change lenses in clean conditions as much as possible.

☐ Put the body cap on when the lens is off.

☐ Regularly check the images on the computer at 100% for possible dust.

☐ If you suspect there is dust on the sensor, follow the camera directions to open the shutter and raise the mirror. Shine a bright light on the sensor at various angles to look for particles.

☐ If there are particles, use a brushless blower, or compressed air gently from a distance. Never touch the surface.

☐ If this fails to remove the particles, take the camera to an authorized dealer.

a perfect analogy, but it effectively conveys the lower threshold of an image, below which the imaging process becomes visible. Resolution depends on the number of pixels; one megapixel is one million pixels, and the number that is possible rises all the time as the technology improves.

Each pixel site responds to the light falling on it by accumulating a small electrical charge, in proportion to the amount of light from black (no exposure) to white (maximum exposure). The cells also record color, but need help for this. The normal method is to filter the individual receptors red, blue, or green, in a pattern across the array. This means that only one-third of the exact color information is being recorded, and the results have to be interpolated by taking information from adjoining receptors.

This may sounds less than adequate, but in practice, and given that the brightness is exact, the results are perfectly acceptable. One reason for this is that human judgement of color, even under perfect circumstances, is a fuzzy and subjective matter. There are very few situations—mostly scientific and in the reproduction of art—when exact color accuracy is important. In almost all photographic conditions, if it looks right, it is.

The charge in all the cells is read and converted into digital form, at which point it can be worked on by the camera's central processing unit, the on-board computer. This is when adjustments such as white-balance correction, sharpening, and image formatting take place. Once this is done, the image is transferred to the removable memory card via a memory buffer. The charge is cleared from the sensor array, which is then free for the next exposure.

Bit-depth

Most consumer cameras use an 8-bit Analog to Digital Converter (ADC) to convert the voltage from each photocell into a value, and so can distinguish between 256 distinct tones between black and white. Professional models use higher bit-depth ADCs and can make finer distinctions: 10-bit divides the range into 1024 levels; 12-bit into 4096. If the sensor has a high dynamic range (the ability to record a wide range of brightness), it can make use of this extra discrimination.

Sensitivity and color

The latest improvements in sensor technology are directed toward better sensitivity and greater color fidelity.

The performance of each photodiode lies in its sensitivity to the light falling on it—not just quantity, but color. The technology is complex, divided between ways of improving capture and ways of processing the signal once it has been recorded. The "fill factor" of a photodiode is the percentage of the pixel site available for accepting light, and is less in sensors that also carry extra circuitry. Micro lenses are one way of improving this "fill factor."

More sensitivity, more noise

Boosting the sensitivity of the sensor makes it possible to shoot in lower levels of light, but it carries a penalty—noise. This is the equivalent of the increased graininess in high-speed films, and, although the causes are not the same, the results are similar. The type of noise from a long exposure of a second or more is known as stationary, or fixed-pattern, noise. There is a do-it-yourself method for reducing this, which involves taking a second shot with the same camera settings but covering the lens, so that the result is black. This second, black, frame has the same noise pattern as the first with the image, so that later, in Photoshop, you can combine the two and use the "black" shot to cancel out the noise. Copy the "black" shot into an Alpha channel so that the pattern of noise becomes a selection. Then adjust the brightness to reduce the noise effect. In advanced cameras, this noise reduction technique is performed automatically when shooting (although it adds to the processing time).

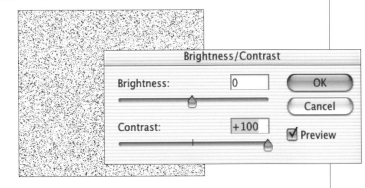

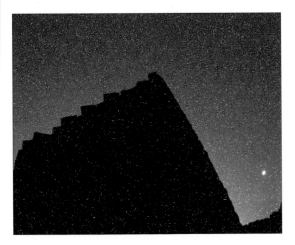

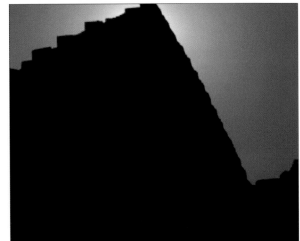

One of the advantages of a digital sensor is that the signal it generates in response to the light falling on it can be boosted, meaning that you can change the standard sensitivity–ISO 100, for example–to a higher level for low-light conditions. The image quality will not be quite as good (*see box opposite*), but will still be perfectly adequate. Some cameras have programs that adjust this automatically in combination with the shutter speed and aperture.

As with film, digital cameras take advantage of the fact that almost all the colors that humans perceive can be constructed from just three: red, green, and blue. This works because these three colors are fairly evenly located across the spectrum: combining them in different proportions produces the in-between hues. The standard technique for recording color in a digital camera is to coat the sensor with a tiled mosaic pattern of dyes in red, green, and blue. Each photodiode is covered with one color so that it captures just that color and not the other two. Because the human eye's resolution and color recognition is highest in green light, the dye pattern is designed so that there are twice as many green pixel sites as there are red and blue. This means that only one-third of the color is captured at each pixel site, and in order to create a full-color image, sophisticated interpolation algorithms must be used. A newer technology stacks three photosensors at each pixel site to overcome this drawback (*see box below*).

Interpolating color

Interpolation is widely used in all kinds of digital imaging to restore missing information. It involves filling in the gaps between accurate, measured pixels by making informed calculations. The procedure for doing this is known as an algorithm, and it varies according to how you want to process the image— for instance, to increase the scale, sharpen it, or add more color detail. In color interpolation for digital photography, the patterns of red, green, and blue colors in the image are processed to make a reasonable estimate of what the color would have been at each pixel in the image.

Three-color sensors

Foveon, a company specializing in digital capture, has developed a CMOS sensor array in which three photosensors are embedded vertically in the silicon wafer at each pixel site. This exploits the characteristic of silicon to absorb color selectively. Green penetrates farther than blue, and red farther than green, and each of the stack of three sensors is sensitive to just one color. This is similar in principle to the standard tri-pack construction of color film, and has the advantage of greater color accuracy than the normal mosaic pattern.

Mosaic capture

The photosensors are covered by a Color Filter Array (CFA), to produce a grid of red, green, and blue pixels.

As a result, each pixel receives information of only one color wavelength—red, green, or blue.

The camera takes the separate color information and interpolates it to create a full RGB signal for each pixel.

Foveon® X3™ Capture

Three photosensors are embedded vertically. Each layer is sensitive to just one color of light.

Blue light penetrates only the first layer, while green light stops at the second. Only red light hits the third.

The result is a true RGB color signal for each pixel, giving a Foveon CMOS the advantage of greater color accuracy.

Color temperature

In photography, color temperature is the usual way of describing the main color differences in light, on a scale from reddish-orange to blue. Digital cameras can compensate for this with their white-balance controls.

Light can be any color, but the most important, daylight, varies in a special way. The sun in the middle of the day appears white; a rich sunset is red; and a clear sky is blue. These colors lie on a scale called color temperature; the range of color changes occurs when a substance is heated. As heat increases, the first sign of color is a dull red glow. The color then becomes orange, and then yellow, until it reaches white heat. Beyond white-hot, the color changes to blue. Some stars burn this intensely, but it is beyond our usual experience.

You can define a color on this scale precisely by referring to its temperature. The reason for doing this is that there are many occasions when neutral (that is, white) lighting is needed. The eye tends to adjust to changes in color: sit under tungsten lighting at night, and before long it appears more or less white. By contrast, the camera's sensor reproduces color exactly as it receives it. In photography, white is 5400-5500K (K = kelvin, the standard unit of thermodynamic temperature), and this is the color temperature of sunlight at midday in summer. The light from a 100-watt tungsten lamp has a color temperature of 2860K. The light from such a lamp will appear quite orange in a photograph. To make a photographic image appear as the human eye perceives the original scene, the opposite color needs to be added to it—that is to say, you would need to add blue to make tungsten lighting look white. This is what the camera's white-balance controls let you select (*see pages 28-29*).

The range of color temperature in photography

The range of color temperature that has practical value is from around 2000K (flames) to about 10,000K (the color of a deep blue sky). The mired shift values are shown alongside the kelvin scale. These can be added and subtracted to calculate differences and which filters to use.

k	Mireds	Natural source	Artificial source
10,000	56	Blue sky	
7500	128	Shade under blue sky	
7000	135	Shade under partly cloudy sky	
6500	147	Daylight, deep shade	
6000	167	Overcast sky	Electronic flash
5500	184	Average noon daylight	Flash bulb
5000	200		
4500	222	Afternoon sunlight	Fluorescent "daylight"
4000	286		Fluorescent "warm light"
3500		Early morning/evening sunlight	Photofloods (3400K)
3000	333	Sunset	Photolamps/studio tungsten (3200K)
2500	400		Domestic tungsten
1930	518		Candlelight

▶ White

The color temperature of midday sunlight is the reference standard for human vision. At 5500K, its illumination is, to our eyes, neutral. Here the colorless white of gypsum dunes in White Sands, New Mexico, appears pure. A scattering of short wavelengths gives the clear sky a blue color; in the shade this illumination alone would have a high color temperature.

Color temperature difference: about 1500K
Light intensity difference: about 4 stops

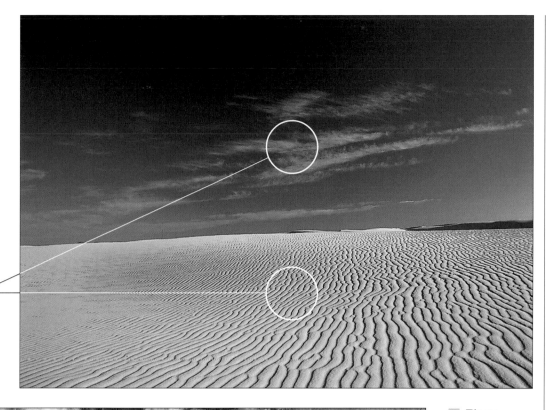

◀ Flame

In the opposite part of the color temperature scale to the blue sky above, flames appear orange and yellow, and are well below 3000K. Although hot in our experience, flames are cool compared with the white heat of the sun's surface.

Meter and exposure

The ideal exposure is usually one in which you can see all the important detail, and which has a good range of tones and saturated colors. Delivering this is the meter's job, but it needs your judgement also.

Exposure is the amount of light that reaches the sensor. Too much light and the photograph will be pale and washed-out; too little and the image will be dark and murky. Getting the exposure right depends on the sensitivity of the sensor, which in most cameras you can adjust (*see page 17*). The built-in meter has the job of measuring the light and working out the exposure, which it will happily do automatically. When the scene is lit strangely, or when you deliberately want an unusual effect, you may need to override the automatic settings. Personally, I like to use a manual meter setting in many situations—it demands more attention to the lighting conditions, but I do that anyway.

Cameras control the exposure with the shutter and the lens aperture. As well as varying the way that movement looks in a picture, the shutter delivers a dose of light—short or long according to its setting. The aperture, which is a multibladed diaphragm set in the lens barrel, cuts down the light when it is closed down. These two mechanisms are linked to the metering system, which measures the light entering the camera from the scene, and sets the exposure accordingly.

Cameras offer different ways of setting the exposure. Depending on the model, you can choose the aperture and the camera sets the shutter speed (this is known as aperture priority); you can choose the shutter speed and the camera sets the aperture (shutter priority); or you can let the camera choose both according to preset rules (program metering). Alternatively, you can do it all yourself and see the over- or underexposure displayed in the viewfinder (manual).

Setting shutter and aperture yourself

Manual exposure gives you direct access to the aperture and shutter settings. As with film cameras, digital cameras link these according to what is called reciprocity. One level more of one matched with one level less of the other gives the same exposure. Aperture and shutter adjustments are arranged in steps. Each full step doubles the exposure in one direction and halves it in the other. The simplicity of this is that you can operate the shutter and aperture in tandem; if you need to use a faster shutter speed without changing the exposure, all that you need to do is open up the aperture by the same number of steps. Say you are shooting at 1/60 second and f5.6 and want a faster speed to deal with a quickly-moving subject. Turn the shutter speed dial two steps to 1/250 second, and the aperture two steps to f2.8—the exposure will stay exactly the same. Advanced automatic cameras are stepless, but still usually show the familiar series of shutter speeds and f-stops in the display.

f-stops

The size of the lens aperture is measured in f-stops. The reason for using this special notation is that the same numbers can be given to all kinds of lenses. Each f-number refers to the same amount of light passing through to the sensor, whatever the lens. For example, f4 on a 35mm lens is actually a smaller aperture than it is on a 200mm telephoto because of the different optics, but the exposure would be exactly the same. The sequence of f-stops looks somewhat strange because the numbers represent the ratio of the aperture to the focal length, but each stop passes half the light of the one above.

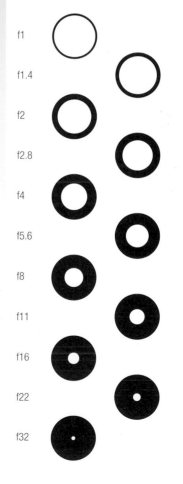

f1

f1.4

f2

f2.8

f4

f5.6

f8

f11

f16

f22

f32

Bracketing

Bracketing means making additional exposures lighter and darker than the metered reading. Normally, a bracket of three would be: +f1/2 stop; normal; -f1/2 stop. A bracket of five would be: +1 stop; + f1/2 stop; normal; -f1/2 stop; -1 stop. This is useful when the exposure conditions are uncertain and when you don't have enough time to check which exposure is right on the LCD screen. Many cameras will do this automatically.

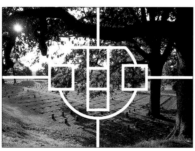

▲ Matrix metering

Matrix, also known as multi-pattern metering, works by segmenting the image area, reading each segment separately, and then comparing the pattern with a "library" of known situations. The overall exposure is adjusted accordingly. Depending on the sophistication of the manufacturer's database of lighting situations, this method is potentially the best at dealing with non-standard scenes, as here, with a sun just shining through the leaves in the upper left.

Metering models

Most built-in meters read the image in such a way as to weight the exposure toward likely kinds of composition, and many cameras offer a choice.

The meter measures the light falling on the sensor in order to gauge the best exposure, but is also designed to favor certain areas of the frame. The reason for this is that in compositions which vary in brightness across the scene—and these are in the majority—the exposure that suits one part will not be right for another. In other words, it depends very much on your choice of subject—something we explore in more detail on pages 30–31. Most camera meters now attempt an analysis of the image in order to second-guess the composition.

Matrix metering, which is also known as multi-pattern metering, is something that has been refined over the years, and is now the most sophisticated of metering methods. In this, the frame is divided into a number of segments, and the value of the lighting in each segment is read separately. The resulting pattern within the frame is then compared with a number of types of photograph that have been programed into the system's memory. If the meter matches your image to one of these known types, the exposure should be near-perfect. Some manufacturers use algorithms of simulated images for comparison; others use a library of real photographs (30,000 in the case of Nikon).

However, you need to be cautious when the view is unusually lit. Matrix metering is based on types of image. The top camera manufacturers pride themselves on researching most possible permutations, but the shot you want to take may not fit the pattern, or it may fit the pattern wrongly. In a minority of cases, matrix metering gets it wrong by assuming that you want a certain kind of picture when in fact you want something else.

The other two metering models, which are not available on all cameras, are center-weighted and spot. Both of these are designed to be used with the photographer's considered judgement, and so, while unrefined in comparison with matrix metering, are more predictable. Center-weighted measurements are taken from an area in the middle of the frame, which may be marked in the viewfinder. The one shown here (*left*), for example, from a Nikon SLR, is an 8mm-diameter circle that feathers off toward the edges and is included in the 12mm-diameter circle shown in the viewfinder. Spot metering is more

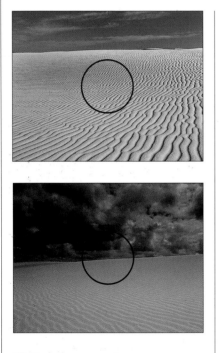

Know your center-weighted area

Choose a scene which, through the viewfinder, is divided sharply between two contrasting tones. In this example, the central circle engraved on the focusing screen of a Nikon D100 measures 12mm. The greatest weight is given to an 8mm circle inside this. To find the exact limits of the weighting, move the camera around while watching the exposure reading, to see how it interacts with the edge in the scene. Once you are completely familiar with the metering bias, you can aim off for any scene to take readings from different areas, or take substitute readings of a completely different view.

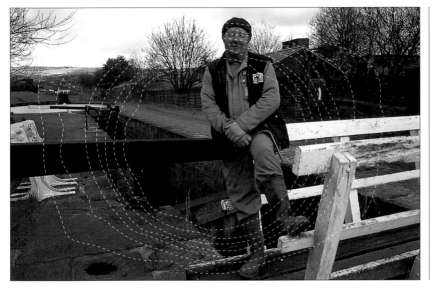

◣◢ Other options

In addition to the matrix metering shown on the previous pages, simpler alternatives that involve less in-camera calculation are center-weighted with a bias away from a presumed sky (above), center-circle (below right), and spot (above right). Spot metering is intended to be used by first aiming the center spot to the area you want to measure, then recomposing.

precise. In both cases you should measure the important area in the scene and then either use the exposure lock to recompose the image without changing the settings, or use manual exposure. Fortunately, you can see the result immediately on the LCD screen and compensate if necessary.

In studio situations and for maximum understanding of light measurement, a handheld meter is unbeatable, although it is the case that the instant feedback from digital cameras' LCD screens has made it redundant for most photographers. A handheld meter enables you to take another light measurement, known as an incident reading. By fitting a translucent dome, you can measure the light, irrespective of the subject, and so can ignore the question of whether the subject is darker or lighter than average.

Histogram

Because the images are stored digitally, they can be measured absolutely precisely. Some cameras have an on-board histogram display, which shows you instantly what your exposure is like.

One of the great advantages of shooting digitally is that it offers you instant feedback: you are able to check the image that you have just taken. This has caused a fundamental change in the way that many photographers shoot, particularly in situations where there is some doubt about the results. Exposure accuracy is one of the main beneficiaries of instant feedback, and by reviewing the shot you can do away with bracketing, even in such uncertain situations as backlighting and silhouettes.

However, the habit of immediate checking can sometimes breed a kind of complacency, and it is tempting sometimes to review the shot too briefly. The LCD screen on the camera has two drawbacks when it comes to assessing exposure. One is the angle at which you view it; if you are several degrees off perpendicular, the image can appear darker or lighter than it really is. The other is ambient light; the best viewing conditions are dark, and sunlight can affect your judgement.

Some cameras have the option of displaying a histogram of each image, and this offers a precise and unbiased reading. A histogram can appear either as a graph or as a bar chart, and shows the distribution of tones in an image, from black at the far left through grays in the middle to white at the right. At first glance this may seem unnecessarily technical and geek-like, but, once you have become accustomed to reading a histogram, you can do it at a glance, often much faster than analyzing the image itself.

Good basic exposure

This is complicated by the many possible kinds of image, but in an average scene with a full range of tones from shadows to highlights, the histogram of an accurate exposure has two characteristics that soon become familiar:

☐ the curve fills most of the horizontal spread, from close to the left to close to the right.

☐ the curve peaks approximately close to the center. In other words, the deep shadows are dark without being completely void of detail; the highlights are almost but not completely white; and the midtones (the bulk of the peak) are in the middle where they should be.

Photoshop histograms

If your camera does not have a histogram view on the menu, you can find one later in an image-editing program such as Photoshop. In this case, one solution to an uncertain exposure situation is to bracket, and then check later on the computer.

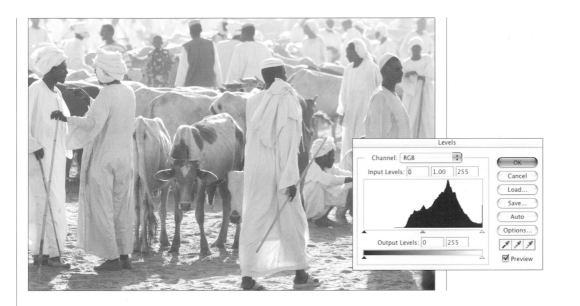

▲ Overexposure

When too much light reaches the sensor, there are no dark shadows and too many washed-out highlights. The histogram shows that the entire curve is shifted right, squashed against the bright end, with a gap at the left.

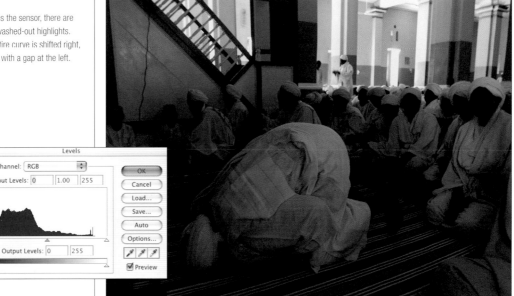

▲ Underexposure

When insufficient light reaches the sensor, the shadows are dense while the highlights are muddy. The histogram is unmistakable—the entire curve is shifted left, crammed up against the end, with a gap at the right.

Highlight check

Some cameras offer another precautionary check against overexposure, by flashing or coloring the bright highlights. Usually, these should be small and few.

Case studies: **histograms**

Learn to read histograms, and life (or at least exposure) will become much easier and more accurate. In particular, learn to read which parts of the histogram relate to which parts of the image. Study the varied examples shown here and you will get a feel for this kind of representation. A histogram is, in a way, a map of the image.

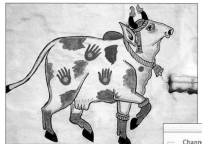

▲ Cow

This Indian mural has mainly pale colors on a near-white background that takes up most of the space. Most of the tones are where you would expect, at far right. The thin line at far left is the small dark hooves and horns.

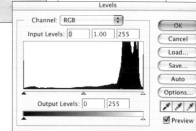

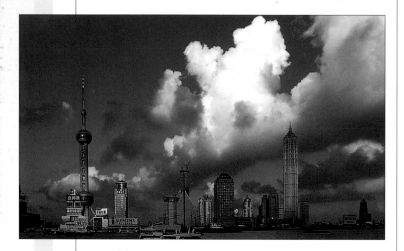

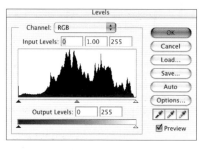

▲ Skyline

This city view with billowing clouds divides into three main tonal groups in the histogram: the largest group is the blue sky and darker buildings, to the right is the pale gray parts of the clouds, and the small area at far right is the white cloud.

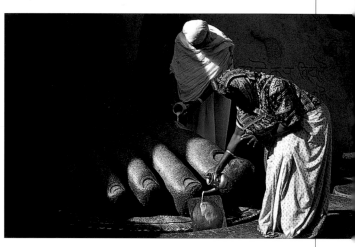

▲ Statue

More than a third of the image is in deep shadow—the tones at far left crowding the edge, showing loss of detail—while the toes and two people carry a range of tones stretching in steps to the right. The small line at far right is the highlights on the white cloth.

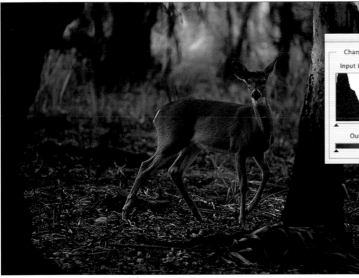

Deer

This histogram is not dissimilar to that of the Indian worshipers opposite—deep shadows with the curve falling sharply away to the right. However, even more of the image is dark here, and while the highlights are important to the image—the small blip at right—the main subject, the deer, is itself dark.

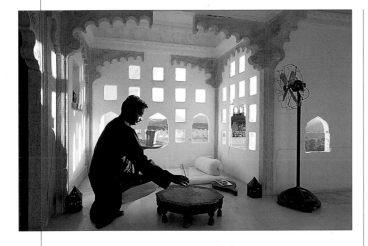

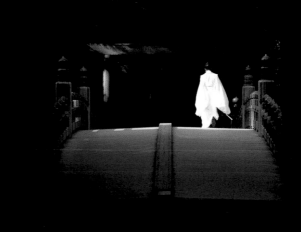

Cocktails

The message from this histogram is that this shot contains several tonal groups, but evenly spread from shadow to highlight. The histogram has no major bias, but a number of smaller peaks.

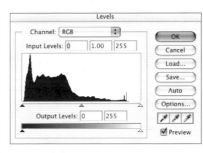

Priest

Three components of the histogram reflect the three obvious tonal groups in the picture: dark surrounding shadow gives the sharp peak to the left, the dark bridge is the "plateau" to the right, while the white-robed Japanese priest is represented by the tiny group of spikes at the far right.

White balance

White balance is digital photography's answer to the different, sometimes unpredictable colors of light. It is a wonderfully convenient solution to getting the overall color of the image as you would like it to be.

Looking back at the spectrum (*pages 10–11*) and color temperature (*pages 18–19*), it's clear that the color of light can vary significantly. Even if our eyes and brain interpret the view so that it looks "normal," more often than not the light falling on objects is somewhat colored: it may be bluish in shade under a clear sky; reddish at sunrise and sunset; tinted by colored surfaces such as a painted wall, and so on. The white-balance controls on the camera's menu take care of this.

The options and controls vary from camera to camera, but the principle is the same. The bright highlights in a scene are the brightest reflections of the light source. Place a white card in sunlight and you will have an accurate reflection of the sun's color. If the sun is high, it will be more or less white. As we saw on pages 10–11, white is as much a state of mind as a physical reality—we perceive it as neutral. Setting the highlights in a scene to neutral white will make the image look "normal," which is to say "correct."

This is what a digital camera can easily do by processing the information collected by the sensor. Think of the white card under different lighting. In open shade under a blue sky it will reflect blue quite strongly, but if the camera is instructed to deal with the image as "open shade," it will compensate so that the card appears white. And of course, all the other colors in the scene will follow.

Testing white balance

The ever-useful gray card is a simple means of checking color balance objectively; this version is from Kodak. Photograph it under different conditions of daylight using at least two of the relevant white-balance settings, including automatic. Then check the RGB values in an image-editing program. They should be equal to each other. The reverse, white, side can be used for white-balance presets.

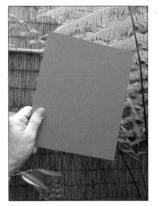

White-balance choices

Digital cameras at their simplest offer a choice of a few typical lighting situations, such as sunlight, cloudy, shade, flash, tungsten, and fluorescent. These are grouped under "White balance" on the menu accessible via the LCD screen. Choose the appropriate one and the results will usually be quite acceptable. Typical color temperature corrections are:-

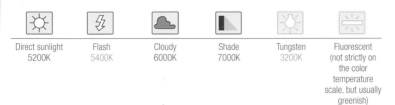

| Direct sunlight 5200K | Flash 5400K | Cloudy 6000K | Shade 7000K | Tungsten 3200K | Fluorescent (not strictly on the color temperature scale, but usually greenish) |

Fine-tuning the WB

Some cameras offer flexible alternatives in addition to the set choices. One of the most useful is the Auto setting, in which the camera analyzes the scene and makes a "neutral" interpretation—that is, with the least color cast overall. This works well in many, even most, situations, although not with a scene that has a strong overall color that you actually want to keep. Another choice is the ability to increase or decrease the color correction manually in increments. More customization is possible using a Preset option, in which you focus on a white surface under the lighting you are about to use, and the camera neutralizes it, remembering the setting for future use.

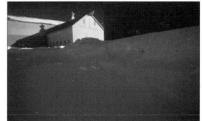

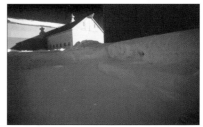

◀ Cloud cover
Overcast skies raise the color temperature a notch, by between about 200K and 1000K. Check the color temperature of the camera's overcast setting in the manual for an accurate idea.

▶ Exercise in correction
The blue of the sky is caused by scattering of the short wavelengths, and is known as skylight. In shade, the eye expects skylight to be neutral—that is, white. Occasionally it is, but usually it's blue to some degree. Don't expect to be able to judge this by eye alone. Shoot a shade situation under an intense blue sky, as in this snow scene, first with the camera's white balance set to sunlight (top), then set to shade (middle), and then to Auto (bottom). The sunlight setting will show you exactly how blue the shade really is—and it may come as a surprise. The other two settings will make a reasonable correction.

Exposure basics

In most situations, the camera's automatic exposure system will deliver excellent results, but the key to getting the exposure exactly as you want it every time is judging in advance how the image should look.

In practice, exposure is a matter of camera settings and meter readings, but the key to being able to make the right exposures easily and consistently is first to understand the criteria; you should first know what an acceptable image is. Ultimately, this depends on personal judgement, and although most people would agree more or less on whether an image appears too dark or too light, there remains a margin of individual taste. It is for this reason that there is no precisely set standard for correct exposure. The idea of correct exposure is a valuable one, but only if you let it be expressed a little loosely.

Under normal circumstances, the best exposure is the one that enables the most information to be recorded. The aim is to produce a photograph that resembles the way the original scene looked to the eye. In a typical view, this means that all the tones are present, from shadow to highlight. The highlights are bright, but still show a hint of texture, and the shadows are dark, but not so dark that they hide their detail. The parts of the scene that looked average in tone—neither bright nor dark—would also look average in the image.

However, there are many views that should appear light or dark, and not average. A white-painted building should look bright and white, not muddy and gray. Equally, a black London taxi cab should look black, not gray. Moreover, there may be a big difference in tone between the subject and its background. In this case, you'll want just the subject exposed correctly, and this may not be easy to achieve if the subject is small in the frame.

It's because of these different potential picture conditions that all serious digital cameras offer the choice of metering systems (center-weighted; spot; and matrix or multi-pattern) that we looked at on pages 22-23. The key to using these is to appreciate that the camera's meter can measure an area and set the exposure accordingly to record the maximum detail, but it does not know how you want the image to look. If you can identify potentially difficult, non-average picture situations, you can compensate. Importantly, exercising control over the exposure means not using the matrix metering, as you cannot be certain how sophisticated it is in any given situation. In such situations, use the center-weighted or spot systems.

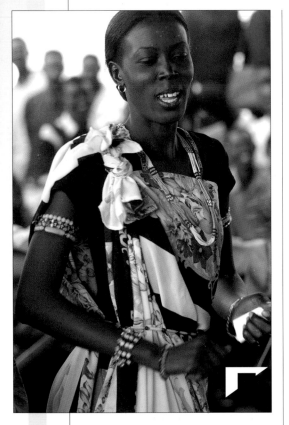

▲ Important tones dark
The key tone in this shot of a Sudanese singer is the woman's dark skin.

Lighting situations

In a simplified form, most scenes in front of the camera fit one of these 12 stylized conditions. High-contrast conditions are the main source of exposure difficulties. Each of these situations is dealt with in detail on the following pages.

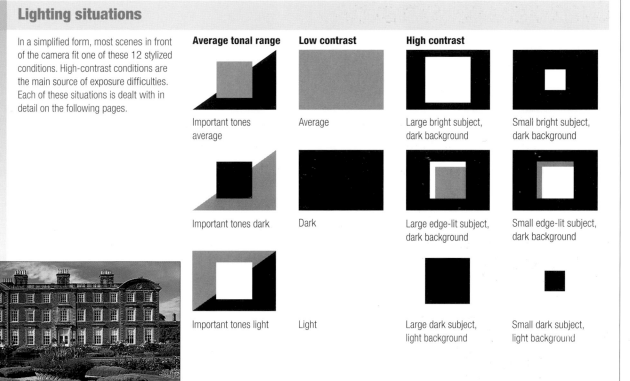

Average tonal range

Important tones average

Important tones dark

Important tones light

Low contrast

Average

Dark

Light

High contrast

Large bright subject, dark background

Small bright subject, dark background

Large edge-lit subject, dark background

Small edge-lit subject, dark background

Large dark subject, light background

Small dark subject, light background

▲ Important tones average
The principal subject in this image is the brick façade of this country house.

▼ Important tones light
The sky makes this shot, and it is essential to hold the whites of the clouds.

Exposure methods that you can control

For hands-on metering, use the center-weighted or spot measurements in any of the following ways:-

☐ Direct reading, no compensation. This is ideal for average lighting conditions and when you want an averagely exposed result.

☐ Direct reading with compensation. With experience, this can work remarkably well. The principle is to take the reading, then judge how much darker or lighter than average you want the result.

☐ Aiming off, to exclude unwanted areas from the metering area.

☐ Substitute readings. Aim the camera at a different view that, in your judgement, is the same brightness as the part of the picture you want to measure. This is useful when the subject is too small for the camera's through-the-lens (TTL) metering area.

☐ High/low readings. Aim off to read the bright part of a scene and then the dark part. Average the two readings.

☐ Spot readings. If your camera does not have a spot-metering system, use the longest focal length on the zoom, or fit a telephoto lens and use the camera like a spot meter. Good for reading small areas.

Case study: **low contrast**

These examples are all flatter than average, either because of the lighting or the subject, or both. Because contrast is low, you can choose how light or dark the image should look.

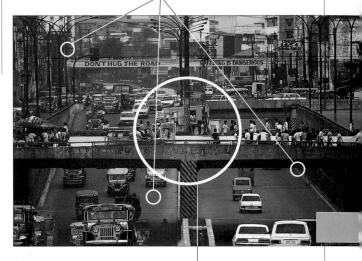

A random selection of spot readings shows consistency to within 1/3 of a stop. There is no reason for taking any measurement other than the camera's average TTL reading.

▶ Low contrast, average subject

This is about as close as you can expect to come to an even tone in normal shooting conditions. The contrast is low to the point of drabness. There are no particularly bright or dark areas to worry about, and no reasons to want anything other than an average reproduction. Any kind of meter reading will deliver the same result.

Even at a glance, it is obvious that the central metering area is completely typical of the entire scene. Reproduced as an average exposure, it will look like this, and the only possible variation is whether to suggest a bright cloudy day (add 1/2 a stop) or an approaching storm (reduce 1/2 a stop). Typically, average scenes like this offer the least latitude in exposure.

▲ Low contrast, dark subject

Because this is a nighttime view, with the subject (pyramids) silhouetted against a rising moon, it should remain dark to be realistic. The brightest area is the glow around the moon, and this has been kept low in tone to avoid the image being mistaken for a daytime shot. Exactly how dark to make it is a matter of judgement, and several versions would be acceptable. In this case, I went for 3 f-stops darker than average, which keeps a sense of the silhouettes only just being revealed.

The moderately bright sky just above the horizon is the only anomaly in this otherwise low-contrast scene.

The camera's center-weighted reading is accurate for the entire scene, as long as the metering circle does not include the sky.

▶ Low-to-medium contrast, average subject

Apart from the skyline, the contrast in this scene is also below average, and the center-weighted area gives a typical reading, as would matrix metering. No adjustments are necessary.

Low-to-medium contrast, bright subject

In this backlit shot of spring daffodils, the sun shining through bright yellow petals makes it necessary to keep the overall tone light. If it had been given an average exposure, the result would simply be muddy. Exposure compensation was +2/3 f-stop.

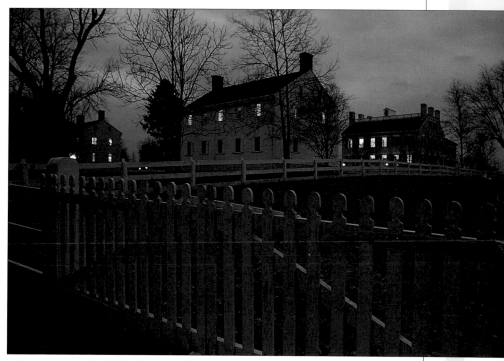

Within the area of this inscribed headstone, any reading will give the same result. The three circles represent different aiming points for the camera's TTL metering circle.

Low contrast, bright subject

Again, contrast is low, but an average TTL reading, if followed, would make this image gray rather than white. Compensate by increasing the exposure by about 1/2 to 2 stops. More exposure than this will cause the texture of the stone to disappear.

Low-to-medium contrast, medium-dark subject

Despite the locally bright windows, the gathering dusk over this Shaker village lowers the overall contrast. To preserve the feeling of twilight, the best exposure is about one f-stop below average.

Case study: **high contrast**

Contrasty scenes bring the risk of losing detail because their brightness range is likely to be beyond the dynamic range of the camera's sensor. The critical judgement is what tones to preserve.

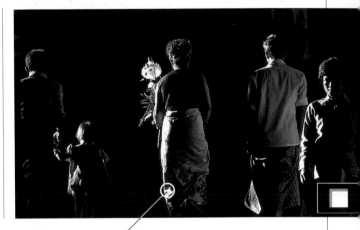

Although a center-weighted reading would be overly influenced by the sky and shadow, aiming the camera slightly off will give a usable reading of the essential parts of the scene. This will still need compensation to avoid underexposure.

The dark blue sky should not influence the exposure measurement.

As a dense black shadow, this area of the picture plays no part in the exposure calculations, and does not need to be measured.

The key tones are these rim-lit highlights outlining the figures. Not only are they too small even for a spot meter reading, but the movement leaves insufficient time. A substitute or incident reading would be the only reasonable alternative.

This brightest face of the building is the key tone. Any exposure calculation must hold this tone as a just-readable white. Too much exposure would give it a washed-out appearance.

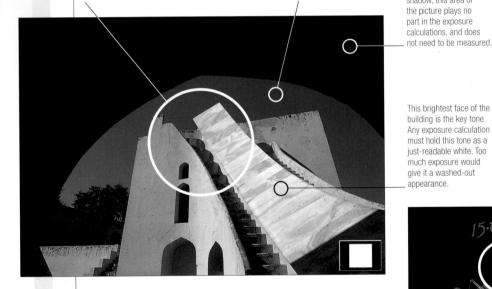

▲ High contrast, subject bright and dominant

Here, the first step is to identify the subject—that is, from the point of view of exposure. Exclude the deeply shadowed frame and sky from the reading by aiming off so as to meter only the pale buildings. The indicated reading would give a fairly dense exposure. For a more average, if slightly less richly colored, version compensate by increasing the exposure by 1/2 to 1 stop.

▶ High contrast, subject bright and small

A reading of the darker part of the gold sign would be accurate, but only possible with a spot meter, a spot reading alternative in the camera's TTL system, or by changing to a long telephoto. Otherwise, make a substitute reading of another surface that is in the same sunlight and of average reflectance and then bracket.

The metering circle in this case is useless.

The key tone naturally is within the small area of the subject. A spot meter reading would be ideal; allowance would then be made to avoid underexposure.

▲ High contrast, subject partially lit

Any direct TTL reading here, center-weighted or spot, has no value. Take a substitute reading of another sunlit area and bracket. In this example, many other photographs had been taken in full sunlight before, when the basic setting was familiar—1/250 second at f5.6 with ISO 64 film. As the highlights are more important for outlining the shapes of the figures than for showing their own detail, the exposure given was deliberately 1 stop over—1/125 second at f5.6.

The area occupied by the subject is too small for the metering circle, even if the camera is aimed off in order to make the reading.

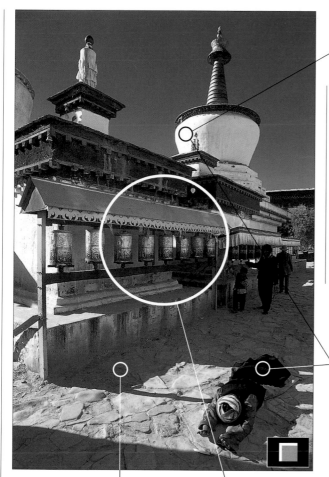

The brightest part of the scene needs to be held. Too much exposure would wash it out.

Given that the metering circle covers both dark and light areas about equally, a center-weighted reading would, in this case, probably be accurate (although bracketing would be advisable). On the whole, an incident reading would be safer.

The contrast range between subject and background is 8 stops.

The contrast range between these two extremes is 6 stops.

The easiest practical method here is to read the background and then open up the aperture by 2 to 2½ stops so that it is held just below the point of being washed out.

◢ High contrast, subject dark and dominant

This high-contrast scene offers considerable latitude for interpretation. Nevertheless, the objective ideal would be an exposure that leaves some tone in the foggy sky, and shows the barest hint of detail in the silhouetted bell. One method is to aim the camera so that the metering area takes in the light sky and dark bell in equal proportions. This is essentially a quick method of approximating a high/low reading. Again, where there is uncertainty, it would be sensible to bracket.

◢ High contrast, subject partly in shadow

Here the bright areas have priority, but the shadow area also needs to be held. Matrix metering would probably work. Spot readings of the brightest and darkest parts would be ideal, but in such a situation there is no time. Or you could take a center-weighted or spot reading of the bright areas and reduce by about 1½ stops, bracketing for safety.

Ideally, this large shadow area should be sufficiently well-exposed to show some detail— about 1 or 1½ stops above the threshold of dense shadow.

A snap judgement from the center-weighted reading would be to reduce the indicated exposure by 1½ stops.

▷ High contrast, subject dark and small

There is no point attempting any kind of reading of the boat, or of a substitute dark area. The most easily available reading is of the bright sunlit water. Take this reading and compensate by adding about 2 or 2½ stops. Less exposure will give you more texture and color to the water, but may absorb some of the outline of the boat. More exposure will tend to introduce flare and a grayness to the boat's silhouette.

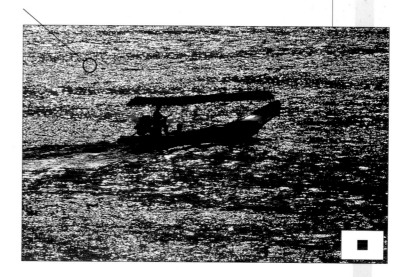

Natural **Light**

The sole source of natural light is the sun. Even the moon is simply a reflector of sunlight, as is the sky. Yet the variety of lighting effects is tremendous; there are so many ways of modifying sunlight that the range of lighting conditions is infinite.

The direction of sunlight is the first variable. The sun moves across the sky, reaching different heights according to the time of day, the season, and the latitude. Add to this the camera angle—facing toward or away from the sun, or with the light shining from one side. The result is an enormous variety of possible angles between sun, camera, and subject.

Before it falls on any scene, the sunlight first has to pass through the atmosphere. It is slightly softened, the more so if it passes through a greater depth of atmosphere, as it does when the sun is low. It is also scattered selectively, so that the sky appears blue, and the sunlight can be any color between white and red. In addition to this, weather conditions filter and reflect the light even more strongly. Clouds can take an infinite variety of forms, while haze, fog, mist, dust, rain, snow, and pollution have their own distinctive filtering effects. Finally, the surroundings themselves alter the illumination by the way they block off some of the light and reflect other parts of it. The net result of all this is that three things happen to sunlight: it is diffused; absorbed selectively (which changes the color); and reflected from surfaces.

One way to think of natural light is in terms of a giant outdoor studio. The sun becomes a single lamp, and the other conditions have their equivalents in diffusing screens, filters, and reflectors. Although you can do little or nothing about where these all are, you can at least move the camera around. Perhaps even more importantly, the better your understanding of how they work and how they change, the more easily you will be able to predict the best lighting conditions for the image that you want to obtain. Choice of viewpoint, timing, and, above all, anticipation are the fundamental skills in using natural light.

Bright sun, clear sky

The most basic, least complicated form of natural light is the sun in a clear sky. Without clouds or other weather effects, the lighting conditions are predictable during most of the day.

The sun's arc through the sky varies with the season and the latitude, but it is consistent. As the sun rises in the sky, the light levels increase. They rise quickly in the morning and fall quickly in the late afternoon, but during the middle of the day they change very little. Once the sun is at about 40 degrees above the horizon, it is almost at its brightest. How long it spends above this height depends on the season and the latitude. In the tropics, this can be as much as seven hours; in a mid-latitude summer, eight hours; and in a mid-latitude winter, no time at all. On a winter's day in the northern USA or Europe, light levels change steadily but slowly from sunrise to sunset. In the summer, the levels change more quickly at either end of the day, but very little for the hours around noon.

The thickness of the atmosphere affects the light's intensity—at higher altitudes, the light levels are higher. The atmosphere also scatters different wavelengths selectively. White light from the sun is scattered, but it is the shortest wavelengths that are scattered the most, and these are at the blue end of the spectrum. So, looking away from the sun, you can see this

▼ **Sunset at airport**
The atmosphere scatters sunlight, most strongly when the sun is low. As the shortest wavelengths scatter the most easily, and these are at the blue end of the spectrum, what remains when we look at a low sun is red or orange. The soft shadows on these airport buildings are lit by the bluish light that has been scattered.

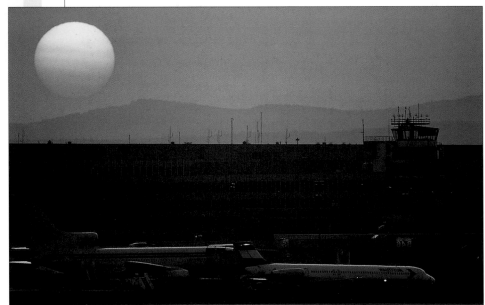

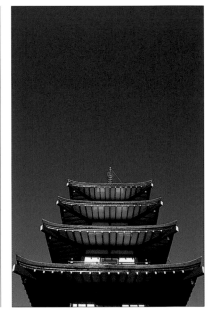

scattering in the form of a clear blue sky. Looking directly at the sun, its color depends on how much blue has been scattered and lost; when the sun is high, very little is lost, but close to sunrise and sunset, when the light has to pass obliquely through a much greater thickness of atmosphere, the light is shifted toward red. The atmosphere close to the ground has the greatest effect on sunrise and sunset, and as these vary locally quite a lot, the colors can differ from place to place and from day to day, between yellow and red.

The effect of the blue sky, which is also known as skylight, is so much weaker than direct sunlight that it is felt only in the shade. It acts as a reflector, and tints shadows. In addition to this on a clear day are the surroundings, which act as colored reflectors, and also the shadows: green grass, the walls of buildings, and so on.

The sky as a studio

In many ways, the sun in a clear sky works for photography like an oversize studio, with the sun as a single light source like a naked lamp, and the surrounding blue sky as a colored reflector. Objects, whether buildings, people, or landscapes, are lit directly by the sun and indirectly by its bluish reflection from the skylight.

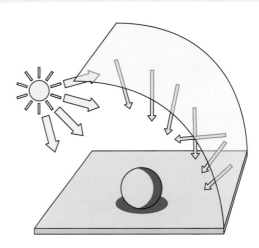

◀ Churieto temple
In the middle hours of the day, when the sun is high, the contrast between blue sky and subject dominates most scenes, as here where sunlight strikes, and reflects off, the roofs of a Japanese temple.

▼ San Xavier
Clarity and sharpness, with details picked out in light and shadow, are typical of clear weather, as in this view of San Xavier mission near Tucson, Arizona. The sky is often darker than the subject—quite the opposite from scenes under cloudy skies.

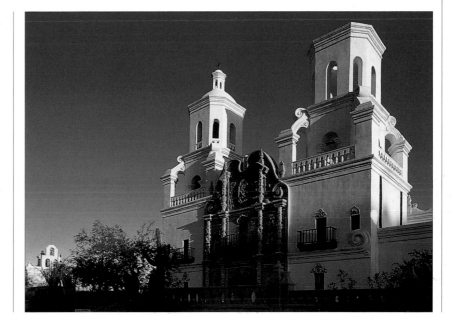

The sun's angle

As the day unfolds, the changing direction of sunlight reveals different aspects of the scene. Some are more appealing than others.

All the possible variations of lighting direction cover a sphere surrounding the subject. In a studio, any of them can be used, but sunlight operates only over a hemisphere (apart from unusual reflections), as shown below. There are, in fact, two directions to consider at the same time: the sun's angle to the camera, and its angle to the subject. Together, they make too many permutations to classify sensibly, and we will concentrate here on the direction that has the main influence on the quality of illumination: the angle to the camera.

Quality of illumination is primarily responsible for atmosphere and the overall image qualities. The angle of the sun to the subject is mainly important for those subjects that "face" in a particular direction, and in revealing plastic qualities such as shape, form, and texture (these are dealt with later, on pages 150-155). The lighting sphere is included here to make a deliberate comparison with studio lighting.

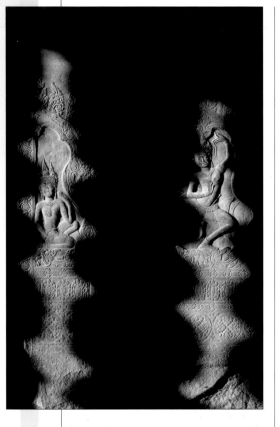

A matter of timing
The precise angle of sunlight becomes important when, for example, it casts shadows for a short time only on a particular subject. In this case, the gaps between stone window bulsters fall on carvings on the wall opposite at the temple of Angkor Wat, Cambodia.

Lighting directions

The direction of light, which outdoors can be from anywhere above the horizon, can be grouped into zones. This "lighting sphere" is segmented to show the main directions, which are dealt with in greater detail on the following pages.

Tropical overhead

Midday temperate

Midday temperate

Edge lighting Edge lighting

Back lighting

Side Side

Naturally, the directions shown are related to the time of day and season. By far the majority of outdoor photographs are taken with a camera angle that is close to horizontal—at least within 10 or 20 degrees. For these, the lighting-sphere diagram holds true. The exceptions are extreme verticals, either up or down. Upward vertical shots, in any case, tend to produce disorientation, and this usually overwhelms other image qualities, such as lighting direction. Nevertheless, backlighting is a common condition of shots like this (the technical recommendations are those on pages 56-57). Downward verticals, particularly over a distance, such as from high buildings and aircraft, are usually of a flat surface: the ground. Lighting considerations for this kind of picture are usually similar to those needed for revealing texture (*see pages 48-49*).

▼ **The sun across the sky**
A single, isolated feature—in this case, a sea arch off the coast of Mallorca, Spain—reveals its different aspects during the course of one day under a bright sun. Reflections in the clear water add to the complexity of the changing image.

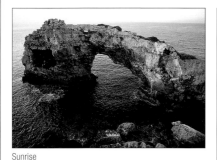
Sunrise

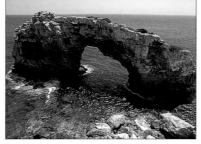
Noon

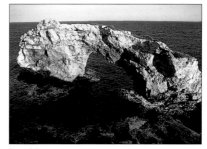
Late afternoon

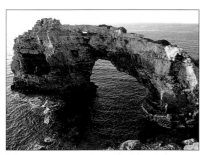
Early morning

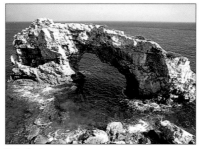
Early afternoon

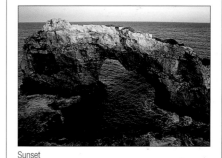
Sunset

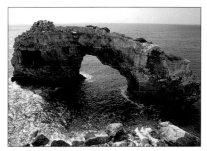
Midmorning

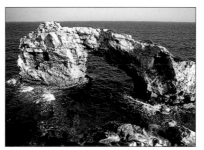
Midafternoon

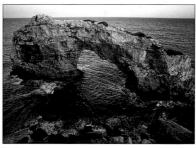
Dusk

High sun

Suitability and esthetics apart, the fairly
high angle of the sun around the middle
of the day has a reputation for being
standard daylight—bright,
but often unremarkable.

As we saw on pages 38-39, the middle hours of
the day, from late morning to early afternoon
(depending on the season), are the most consistent in
terms of light level, quality, and color. However, there are
some photographic problems with a high sun; one of
them being that images taken in these conditions have a
quality of light that is overfamiliar and certainly not
inherently exciting. This is a typical viewer reaction,
anyway; because so much photography concentrates on the new and the
interesting, there is an undeniable visual premium on unusual and striking
lighting. High midday sun is certainly not one of these.

However, it is important not to go overboard with the idea of spectacle for
its own sake. Dramatic lighting effects are only powerful in comparison with
a variety of other conditions, and it would be wrong to think that a midday
sun is good for nothing. The positive qualities of using midday light for
photography are that your images will have a crispness and detail that are
bright and definite. As long as the shadows contain nothing too important,
this is a good opportunity for making straightforward images. In general,
subjects with a strong intrinsic form—that is, in shape or color—photograph
well in this light. If the air is clear, the precision of the image is heightened, as
in all the examples shown on these pages.

One of the principal difficulties with shooting in high sun is coping with
the way that shadows fall. The higher the sun, the more they fall underneath.
This lighting is not particularly suitable for photographing people, as the
shadows tend to hide the subject's eyes, which are so important in portraits.
It also tends to be unflattering, which becomes a problem if the photograph is
intended to be a pleasing portrait, rather than a piece of reportage.

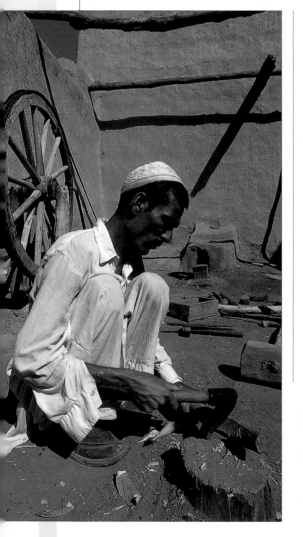

◄ Holding the highlights
The contrast range in this shot of a Pathan craftsman
was high at about 6 stops: the highlight reading, taken
from his shoulder, was f32; the shadow reading, taken
from his neck, was f4. However, his white clothes are
such an important part of the image that they control the
exposure setting; overexposure would be unacceptable.
This exposure gives deep shadows, but the viewpoint was
chosen so as to keep these small.

◢ Graphic pattern

Bright, clear weather adds to the complexity of this
street corner in Jaipur, India, by throwing extremely dense
shadows. The stark, graphic effect produced is visually
interesting in itself.

▶ Vertical surfaces

A high sun gives raking
light on walls and other
vertical surfaces, and, in
the case of important
texture such as the
bas-relief here, can be
extremely useful. The
effects shift rapidly,
however, so timing is
critical. As the sun
passes over a building,
the light leaves one
wall and passes to
the opposite.

Flat scenes become flatter

With many subjects, a high sun simply reduces the modeling effect
that might have been useful for showing form and volume. Flat,
horizontal subjects, like level landscapes, suffer as much as any:
shadows are minimal, showing little texture. The answer is to look
for strong shapes and colors that don't need this kind of modeling.

Skylight

Indirect lighting from the sky—that is, when the sun is shaded by an obstruction—is soft and potentially attractive, but its color varies widely.

Traditionally, artists' studios were built with large north-facing windows because the gentle illumination was consistent. Known as "north light" or skylight, this light may appear to the eye to be consistent, but in reality it has very unreliable color properties. This meant that it was generally avoided during the days of color film, but fortunately digital cameras can easily neutralize the color. As we have seen on pages 38–39, skylight is blue because of the scattering of short wavelengths in the atmosphere. The blueness varies with the weather conditions and the altitude (it is more blue in the thinner air of mountains). Its effect is weakened by clouds and by any bright object, such as a white building, that reflects sunlight. Although skylight is what remains on a sunny day when the direct sunlight is blocked, it behaves, from the point of view of taking pictures, as a light source in itself.

Skylight is most important when you are photographing entirely in shade. What happens in this situation is that, because there is only one kind of illumination visible and it is consistent, the eye expects it to be neutral in color; in other words, white. Occasionally it is, but more often it is not, and

The range of blue sky

The color temperature of skylight covers approximately the range shown here. In the first panel, the atmospheric conditions are clear and dry; the intensity of the blue depends on altitude, season, position of the sun, and which part of the sky you look at (normally the higher, the more intense). In the second panel, the blue is diluted by increasing amounts of haze. Broken cloud in the third panel reduces the overall color temperature; this varies with how bright the clouds are and how much of the sky they cover. Finally, the surroundings may obscure some or most of the skylight, and if they are pale in color and sunlit themselves, they can virtually take over as the light source.

Clear sky 12,000–7000K

Haze about 6000K

Variable cloud about 5700K

Pale Surroundings about 5400K

that is when the white balance of a digital camera comes into its own. The "shade" setting can vary according to the manufacturer, but is typically around 8000K. Some camera menus let this be raised or lowered. Remember that the eye is a poor judge of color temperature in shade, but check to see how blue the sky looks, as this makes up most of the illumination, added to by local reflecting surfaces (such as walls, sand, or water).

Sun and shade

This pair of photographs of a wallaby, taken within minutes of each other, shows the typical difference in light level and color temperature between sun and shade on a bright day. To the eye, the color of the animal when in the shade would seem neutral; in the image, we can see the distinct blue cast from the skylight.

High-altitude blue

In mountains and in clear weather, there is less atmosphere, less haze, and more ultraviolet. When the sun is low in the early morning and during the late afternoon, shadow areas easily dominate a scene, as in this Andean village, and reflected blue from the sky takes over.

Morning and afternoon

A lower sun makes life more interesting for photography. There is more variety than with midday sun, because the sunlight interacts more with buildings, people, and objects, and you can choose different camera angles to it.

For striking, immediately attractive lighting, the morning and the afternoon are some of the best times of day for shooting. Instead of everything being bathed in the same light from above, there is more local interest as the sunlight strikes the sides of objects and casts less predictable shadows. The lower angle of the sun is more flattering to most subjects than that around midday. In addition, while the sun—when it is well clear of the horizon, but not really high—may lack the potential drama that it has around dawn and dusk, it still gives attractive and more reliable lighting. The color is nearer a neutral white and, if you find a long run of orange- and red-hued images exaggerated, it is more straightforward. If a true color rendering is important, shoot when the sun is at least an hour or two away from the horizon.

▷ Shooting down

An overhead camera position can be a good option in this light. In this case, the contrast is usually much less because of the ground, or whatever surface the subject is resting on, but the texture remains strong. In addition, the long shadows make for interesting graphic compositions.

Make full use of the sun's lower angle by choosing its angle to the camera: behind, in front, or to one side. The visual effects are quite different, and are more accentuated when the sun is closer to the horizon. Silhouettes made by shooting into the sun are covered on pages 58–59, but in midmorning and midafternoon you need tallish subjects for best effect. The most characteristic lighting effect at these times is side lighting, which can be both dramatic and useful, and we explore this more fully on the following pages.

Wall details

Cross-lighting reveals texture at its strongest. Just as some vertical surfaces receive this at midday, others are at their best early and late in the day, as with this bronze fitting on a wooden wall. Here, the window of opportunity was only a few minutes long before the shadows covered everything.

Horizontal light and shade

The visual play between highlights and shadows is an important component of photographs taken at these times of day. Shooting at right angles to the sun makes the most of this effect, and adds a linear, horizontal component to the image.

Using shadows

The shapes cast by shadows when the sun is fairly low can be put to good graphic use. In this morning shot of an old French abbey with a garden of lavender, the foreground shadow makes a solid base for the composition; the middle-ground shadows of trees suggest the unseen forest at right; and the shadow cast by the conical roof continues the lines of the hill beyond.

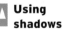

Side lighting

Of all the types of direct sunlight, side lighting is probably the most useful when it is important to bring out modeling and texture in the subject, and this is all down to the way that the shadows fall.

Shadows are the feature of side lighting that stands out the most, and it is these shadows that show the relief of surfaces and objects. As the two diagrams below show, shadows appear longest to the camera and most distinct under side lighting. The other condition under which the sunlight is at right angles to the camera's view is when the sun is overhead, but, in this case, the ground limits the extent of the shadows, and also tends to act as a reflector to fill them in.

The shadows from side lighting have three effects. The first is that the shadow edge traces the shape of the front of the subject, and so has a modeling effect. You can see this in the photograph of the two women on the opposite page. The second effect is on surface texture. Shadows are longest under side lighting, and so the small ridges, wrinkles, and other fine details of a surface show up in the strongest relief, as in the photograph of the paper lantern opposite.

Light and shade

Side lighting produces the most distinct shadows. This sequence shows what happens as the direction of sunlight moves from frontal to back. The shadows are smallest from the camera's viewpoint in frontal lighting, while in backlighting shadows dominate to the extent that there are few sunlit parts to give local contrast. The maximum light/dark contrast is when the sun is at right angles to the camera.

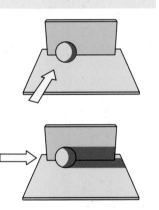

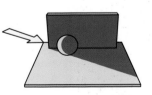

High contrast

High contrast is typical of many side-lit scenes. The lighting is at right angles to the view, and thus the shadows are too. As the diagrams show, a surface needs to be angled only slightly away from the sun, or be shaded by quite a narrow obstruction, to give a high light/dark contrast.

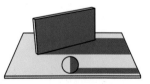

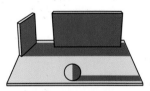

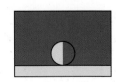

The third effect of side lighting is on contrast. If the sky is clear, and there is nothing nearby to reflect the light, such as buildings, the contrast between light and shade will be high. Moreover, as the diagrams opposite show, it needs very little to change a lit background into a shaded one, and a dark setting will help a side-lit subject to stand out very clearly. The photograph of the two women illustrates both of these points.

Getting the exposure right

Light measurement and exposure depend on the shape of the subject and on the proportions of highlight and shadow. If a major part of it faces the sunlight, then expose for this. This situation is where matrix metering comes into its own, but you will need to check the result carefully on the LCD display. Alternatively, measure just the lit areas (in spot or center-weighted mode if your camera has these), using exposure lock to hold that setting when you reframe the shot. If, on the other hand, what you can see of the subject is virtually flat and facing the camera, an average reading will produce successful results.

▲ Light and texture
The angle of this Japanese lantern's paper surface changes gradually from left to right, and this affects the amount and distribution of shadow. The strongest impression of textural detail is when the sunlight grazes the surface at a very acute angle. Broadly speaking, there are three areas of texture detail in the shot of the lantern, with light readings as follows: left = f16; center = f11; right = f4. The area of maximum texture detail is in the center.

▲ Sharp outline
One of the most effective uses of side lighting to outline a subject depends almost entirely on the camera viewpoint. In this shot taken in a Montreal park, the sun is at right angles to the view, and the background is in shadow.

◄ Raking light
In this shot of a yogurt dish, photographed from directly above, side lighting establishes the texture—an essential quality in food photography, where any tactile sensation helps to stimulate taste. A white card on the side of the dish opposite the late afternoon sunlight opened up the otherwise strong shadows.

Low sun

In clear weather, the times of the day when the sun is close to the horizon can produce some spectacular lighting on landscapes. To take advantage of this, be prepared to shoot quickly and move the camera as the light changes.

The most concentrated periods for working with the changing angle of the sun are at the beginning and end of the day, generally within an hour either side of the sun crossing the horizon. Every quality of the light changes: direction; diffusion; color; intensity. It is usually unpredictable because of atmospheric effects and clouds, which reflect the light. In high latitudes, the sun stays close to the horizon throughout the day in winter, making cold, clear days perfect for photography.

All the remaining directions of sunlight are those of a relatively low sun. Low in this case means no more than about 30 degrees above the horizon, and in most of the examples shown here, no more than about 20 degrees. In a mid-latitude summer, this is before 6 o'clock in the morning and after 6 o'clock in the evening. The special value of a low sun is that it offers a choice of four major varieties of lighting quality at once—frontal, side, back, and rim. All four types of lighting can be found at the same time, with the same position of sun.

In addition, there is also the old cliché of using the setting (or rising) sun itself as the main subject of an image. The sun on the horizon seems an irresistible subject for many people, as evidenced by the number of "sunset viewpoints" at tourist spots around the world. Watching the sun go down is a time-honored pastime (watching it rise demands more discipline), but turning this into a good photograph means finding a graphically interesting setting, not a featureless horizon. A long telephoto lens comes into its own in such cases.

◄ The sun's reflection

The red column of light here is effective for two reasons: it neatly encloses the silhouette of the boy wading through the shallows; and the heavy haze makes it contrast less with the surrounding water.

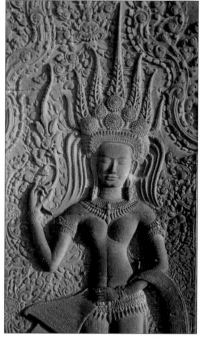

Warm tones
Normally an undistinguished gray, the sandstone into which this Khmer bas-relief has been carved acquires a rich golden glow in the early morning sunlight.

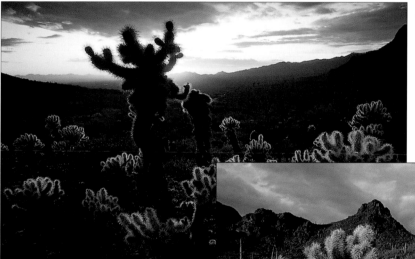

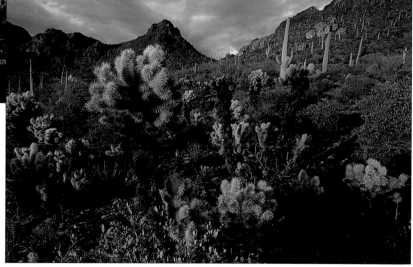

Cholla cactus
These three shots of a clump of jumping cholla cactus were all shot within minutes of each other as the sun was setting over Saguaro National Monument near Tucson, Arizona. The lighting effect is quite different in each, according to the viewpoint, between backlighting, frontal lighting, and side lighting. This illustrates one of the valuable qualities of a low sun—the variety that it offers to the camera.

Frontal lighting

Light that is full on the subject casts no obvious shadows, but brings out all the differences in color and tone at their strongest, as well as intense reflections.

Frontal lighting is when the sun is directly behind the camera. If you use it well, this can be very powerful and colorful, but the difference between creating a successful and an unremarkable image is more delicate and less predictable than with the other varieties of low sunlight. Being frontal, the sun in this position throws shadows away from the camera, and if the viewpoint is exactly along the lighting axis, they will be invisible—like using on-camera flash but covering the entire scene. As shadows are responsible for modeling and texture, and help with perspective, the character of frontally sunlit shots tends to be flat and two-dimensional. This is almost a prescription for a dull effect, but what can make the difference is the color and tone of the subject, and the intensity of the sunlight.

When the lighting is intense and is behind the camera, the most immediate quality of the picture is the strength of the colors. With real frontal lighting, this effect is even stronger, with the addition that the color temperature is lower, and the light more yellow-orange. This means that the contrast of both color and tone is high. If these are already inherently powerful in the subject, as in the picture of the Japanese woman shown on this page, the combined effect is very strong. Reflections jump out in these conditions, sometimes too strongly, but look for the effect on any surface that has shiny or iridescent qualities.

Richness of color
The contrast between the black silk and gold embroidery is already strong. Frontal lighting enhances this by illuminating the glossy embroidery as strongly as possible.

Mirrored contrast
Shooting straight into a highly reflecting surface, such as this mosaic of mirrors, will give extremely high contrast, so that any matt surfaces appear almost as silhouettes, as in this decorative detail.

Your shadow

When the sun is almost on the horizon, and provided that it remains bright, shadows begin to appear and can soon cover everything. This means that your own shadow will appear, which is usually unwanted. One solution is to alter the shape of the shadow you cast, so that it appears natural and indistinguishable (for example, withdraw your arms, duck your head, or cover over tripod legs). The other is to move so that the lighting in the picture is not exactly frontal. In the case of the shot of the cemetery here, slightly off-axis lighting produced graphically strong shadows that edged the lit shapes and could be used in the design of the image.

▲ Flat graphics
The lack of shadows when the sun is directly on the camera axis can work well with strongly colored or contrasting subjects if you treat the composition as two-dimensional, ignoring perspective and depth.

▼ Bright reflections
Shiny surfaces such as the gilding on this northern Thai temple, which faces east toward the sunrise, leap out of the picture for the short period of time that they catch the light.

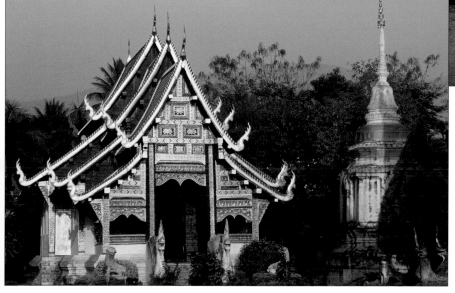

▲ Shadow shapes
Narrow but hard shadows from a setting sun almost behind the camera play an important part in a view of a Shaker cemetery near Albany, New York. It was necessary to position the camera carefully to prevent its shadow from appearing in the photograph.

Case study: **frontal light**

Frontal sunlight is short-lived. Even when you have found an appropriate scene and viewpoint, the weather and atmosphere control everything. For this frontal lighting project, I chose a viewpoint that offered clear shooting of a subject opposite the sun. It is important that no shadows fall across the subject at the last moment. This means that large subjects, such as buildings and mountains, are more reliable in this respect.

The scene is downtown Perth, in Western Australia, in the 45 minutes before sunset, and the viewpoint is a well-known site. The main lesson here is the unreliability of very low sunlight; it's very hard to predict. Not only can clouds cross in front of the sun, but the clarity of the atmosphere close to the horizon can vary. All of this has a particular importance for frontal lighting. The difference between the brightly lit shot and the last, clouded version is remarkable. In an instant, all the richness and interest had gone. The lighting direction remained frontal, but weak and diffused. Compare this with backlighting and side-lighting conditions, both of which can often continue to work reasonably well when the light is weakened by clouds. Frontal lighting, however, really needs the intensity of a direct sun and, ideally, clear air. Without this brightness, many frontal sunlit pictures become pointless.

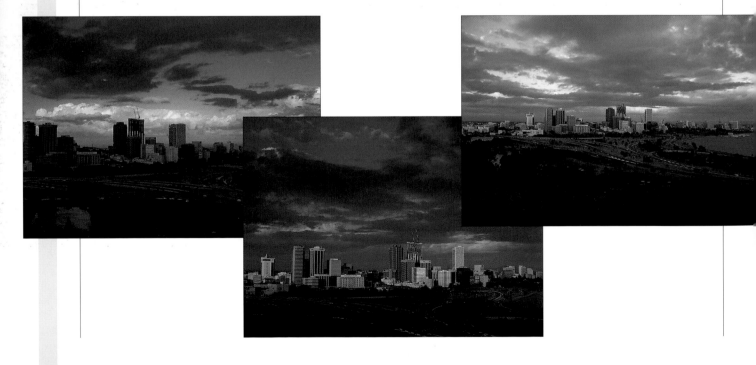

▶ Rapid
▼ changes

As the sun moves sideways, its reflections intensify in the plate-glass windows of one office block. A long-focus (400mm equivalent) lens crops in on the reflections.

At the last moment, clouds drifted across the sun, and the entire scene died.

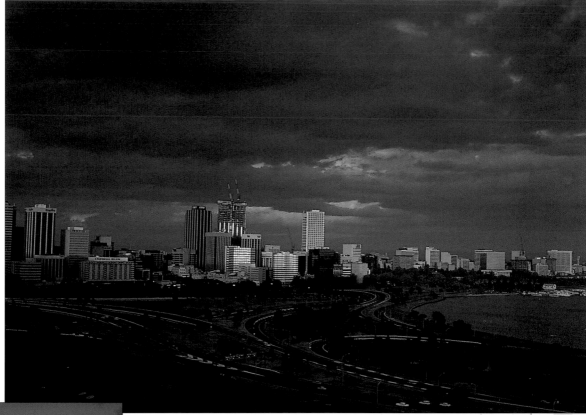

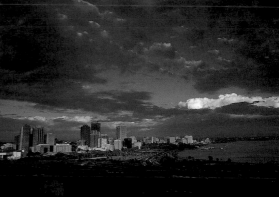

Into the sun

Backlit photographs are intrinsically dramatic and exciting, although as with any other distinctive technique, their strength and appeal also lie in being applied sparingly.

Shooting into the sun gives a photographer some of the best opportunities to create atmospheric and abstract images. The hallmark of direct shots is the silhouette, in various forms; this can be powerful if you take care to show a clear shape and expose appropriately. Off-axis shots, with the sun only just out of frame, can give a more interesting and unusual range of images, which draw very much on the texture of surfaces to produce their effects.

There are four types of lighting conditions that can be classified as backlighting. One is a direct shot into the sun and another a direct shot into a *reflection* of the sun. The other two types are off-axis shots; one normal, usually with the horizon visible; and the other, which is a

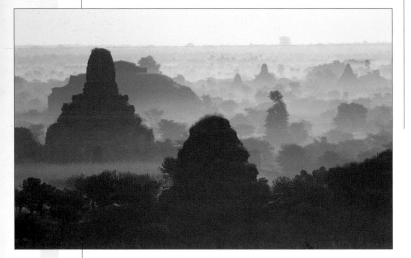

Receding planes
A light morning mist combined with backlighting creates a strong aerial perspective in this view of ancient pagodas in Burma, by progressively softening the silhouettes with distance.

Types of backlighting

There are four basic kinds of effect when shooting toward the sun, depending on the height of the sun and the camera position. Shooting directly into the sun produces a hard silhouette against a concentrated area of brightness. A higher angle into a reflective surface, such as water, also gives a silhouette, but the bright background will be larger. When the sun is higher and out of frame, some shadow detail can be retained. With rim lighting, the background is dark enough to show the brightly lit edge of the subject.

Directly into the sun

Into the sun's reflection

Slightly off-axis

Rim lighting

slightly special condition, with a dark background that throws up the lit edges of the subject in sharp contrast.

When you take a direct shot into the sun, the contrast will almost certainly be extremely high. Even accepting that any subjects in the foreground or middle distance will be very dark, you will usually have to lose legibility at both ends of the brightness scale. The photograph of the beached fishing boat below is fairly typical of a wide-angle shot that includes both the sun and a main subject. Here you can see what is being lost in the distant light tones and in the foreground shadows. The brightness of the sun causes a loss of richness in the color; the boat lacks full detail. Note, however, that these are technical points and are not necessarily damaging to the overall effect of the picture; in fact, the atmosphere generated by the use of backlighting in this image is very successful.

There is one ameliorating condition: the light clouds on the horizon, which have helped to weaken the intensity of the sun. In addition, two actions were taken to reduce the top-to-bottom contrast. One was simply to wait until the sun was low enough on the horizon before taking the photograph. The other was to use a strong neutral graduated filter, sliding it up in its mount in front of the lens until the soft edge of the dark tone was aligned with the horizon (*see pages 76-77*).

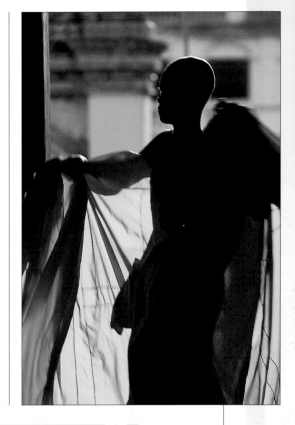

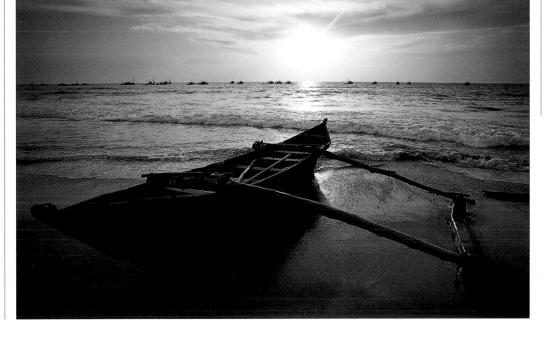

Intense color

Backlighting through anything translucent brings out richness of color—as in the case of this monk's saffron robe—as long as you avoid overexposure.

Filtering the sky

This shot of a boat into the setting sun had such high contrast that it needed a neutral grad filter to darken the sky.

Silhouette

Silhouettes are a special case when shooting into the sun and, provided that your subject has an obvious profile and hides the sun, you have the makings of an arresting image.

▶ Sun as background

The silhouette of the caddis fly in the main picture below was shot with a macro lens at 1/2 x magnification, and at full aperture—f2.8. At a smaller aperture of f16, the diaphragm blades' shape deforms the sun into a polygon and makes it appear smaller, spoiling the silhouette.

The high contrast from backlighting is exactly what you want if you wish to create a silhouette image. To work well, this kind of photograph depends on the shape of the subject and on the coordination of two principal tones: black, and the light background. One of the key conditions is that the outline of the subject is strong, clear, and recognizable, which is not always easy to arrange, as the subject also needs to be positioned between you and the sun.

Exposure in this circumstance can be tricky, for a number of different reasons. Silhouettes taken directly into the sun normally hide the image of the sun itself, as the shot opposite of the dockside crane demonstrates. In a clear sky, the brightness around the sun is highly localized, so that severe underexposure, particularly with a wide-angle lens, will make the sky quite dark toward the edges of the frame. This will lose any silhouette outline away from the center. If the silhouette is small in the frame, and you use a telephoto or macro lens, you can outline an object against the sun's disk itself, as with the image of the caddis fly shown on this page. In either case, a range of exposures will work, and it is worth experimenting with bracketing.

The other type of silhouette is where the image is taken against the sun's reflection, usually in water. One advantage with this is that, unless the water is perfectly calm and flat, it will have a slight diffusing effect on the sunlight. Instead of there being a concentrated patch of brightness, the background will appear to be larger and more even. If you use a telephoto lens, as I did for the photograph of the moose on the opposite page, this background can fill the frame, while the outline of the silhouette appears clean, sharp, and obvious. A further advantage with this situation is that the necessary higher camera viewpoint gives a view that is angled slightly down, and it is often easy, as was the case with this example, to isolate the image of the silhouette completely. This is usually more legible than having the silhouette merge with an equally dark ground-level base.

Silhouette exposure

Make all the practical light readings that you can for a silhouette shot, and then bracket the exposure widely, shooting several frames. The normal criteria for judging exposure do not apply here. In a high-contrast silhouette shot, there is no midtone area that needs legible exposure. The subject is the silhouette, and so the clarity of the outline is the standard. The absence of a midtone gives you a certain freedom of choice in the exposure, which is why you should bracket very widely, over several f-stops. You will probably find that more than one exposure looks acceptable. The upper limit on exposure is usually when the density of the silhouette weakens noticeably into gray and when the edges of the outline begin to lose definition due to flare. The lower limit is when the background becomes dim, obscuring the silhouette's outline. However, you might find that overexposure in some situations creates an attractive, ethereal effect.

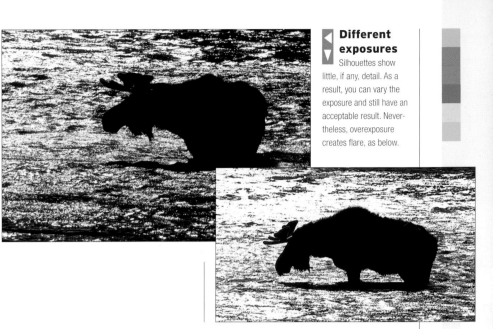

Different exposures

Silhouettes show little, if any, detail. As a result, you can vary the exposure and still have an acceptable result. Nevertheless, overexposure creates flare, as below.

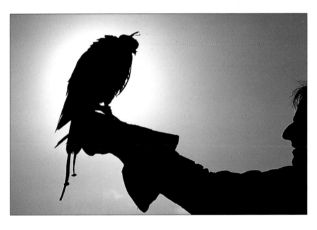

A clean silhouette

For a simple dark-on-light, two-tone silhouette of a hawk on the gloved hand of a falconer, I used a medium telephoto and a viewpoint that concealed the sun's disk behind the bird.

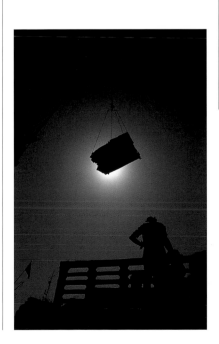

Wide-angle silhouette

The treatment of this dockside silhouette is basically the same as that for the falcon, with the key difference that the lens is wide-angle. This takes in more of the much darker surrounding sky.

The sun's reflection

Any surface texture tends to diffuse the reflection and spread the bright area, as in the photograph of the moose above. The angle of reflection is critical. Either move higher or lower, or wait for the sun's position to change.

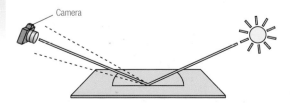

Camera

Edge lighting

Highly atmospheric and striking effects are possible to achieve when the light strikes your subject from behind but slightly to one side.

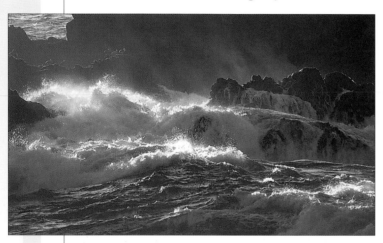

▲ Overall back-lighting flare
Lens flare creates the warm glow that suffuses this telephoto view (taken with a 400mm lens) of waves breaking at Point Lobos, near Carmel, California. Whether you see this as a problem of weakened contrast or as a pictorial addition is largely a matter of taste.

Tip

If you are shooting into the light with the sun only just out of frame, hold your hand or a piece of card as far forward as you can reach, just out of frame. Better still, if the camera is on a tripod, stand in front and make sure that the shadow you cast just covers the lens surface.

Off-axis backlighting can give considerable atmosphere to a photograph, with a glow softening the high contrast. This glow is in fact a mild flare, and so needs to be kept under control. Flare is by no means always something to avoid, but you should be certain that the effect you get is really what you want rather than a lowering of image quality. The two hallmarks of flare are a line of bright polygons across the frame and an overall haze that weakens contrast and color. The first of these is caused by light striking the aperture diaphragm inside the lens. Flare also happens if your subject is surrounded by white—a close-up in the snow, for example, or a typical still-life "product shot" set against a white surface (there is more information about this on pages 138-39).

You can make a quick check for flare before shooting by lowering one hand in front of the lens; see if the picture in the viewfinder becomes crisper and slightly darker just before your hand comes into view. In fact, your hand, or a piece of card, will make an effective mask for flare, but in any case you should fit a lens shade, of one of the types shown. In most situations, photographs look better when the lens is shaded, but you can also make flare work to your advantage. With a telephoto lens, the overall flaring tends to spread light, and sometimes color, all across the image. The flare from an orange setting sun can look very attractive. If there are any pinpoint lights or reflections in the view, flare can sometimes give them a halo—you can even exaggerate this effect by smearing a very light film of grease on the lens (in practice, on a filter in front of the lens). Occasionally, the overlapping string of bright polygons and other streaks of light can add to the feeling of the sun's intensity. As always, experiment for yourself.

The special condition of off-axis lighting is rim lighting, in which the light reflects off the very edges of the subject, creating a bright rim, as in the picture of the men in uniform here. In order to work visually, however, it needs a dark or fairly dark background to show up the subject's bright edges.

◀ Translucent fish

These dried fish are lit at their edges by the sun, which also shines through them to silhouette their bones. The camera was placed so they appeared against a background in shadow.

▼ Rim lighting

At a very low angle, almost into the picture frame, the sun creates a rim-lighting effect. How brightly the edges appear depends strongly on the texture of the subject—here, cloth uniforms.

Reducing the risk of flare

☐ Use a lens shade. Fit a customized shade made either by the camera manufacturer for your particular lens or by an independent make. The most efficient lens shade is one that masks right down to the edges of the picture frame, and so is rectangular and adjustable, like a bellows shade. Many telephoto lenses have built-in shades that slide forward.

☐ Keep the lens clean. A film of grease or dust makes flare much worse. Check the lens and wipe it.

☐ Remove any filter. Filters, however good, add another layer of glass that increases the risk of flare. Try removing any that might be fitted.

☐ Use a properly coated lens. High-quality multicoated lenses give less flare than cheaper ones. Use the best optics you can.

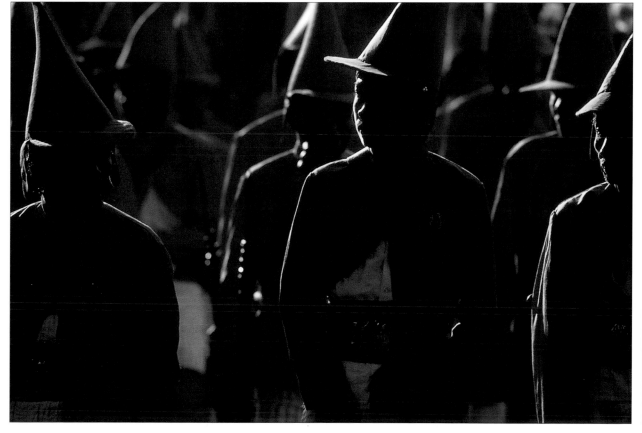

Sunrise and sunset

During the time in which the sun rises or sets—usually no more than an hour— the light can change dramatically, revealing different picture opportunities for different lens focal lengths.

Variety and unexpected effects are the keynotes here. Whether you shoot at sunrise or sunset will probably depend on the location. You can expect the greatest variety when you shoot into the sun, and few scenic locations offer a 180-degree choice of direction. Apart from the actual direction of shooting, which is obviously vital in making the photographs, the differences in lighting quality between sunrise and sunset are indistinguishable to anyone else looking at the images. During shooting, however, the times feel quite different. Fewer people are familiar with sunrise, which is a good reason in itself for shooting then—and in most locations you'll find few people around at that time.

▼ Silhouettes
Shooting into the sun as it rises or sets creates obvious opportunities for silhouettes. These are easiest with a wide-angle lens, which makes the image of the sun small, and so easy to hide behind a feature such as this Shanghai tower.

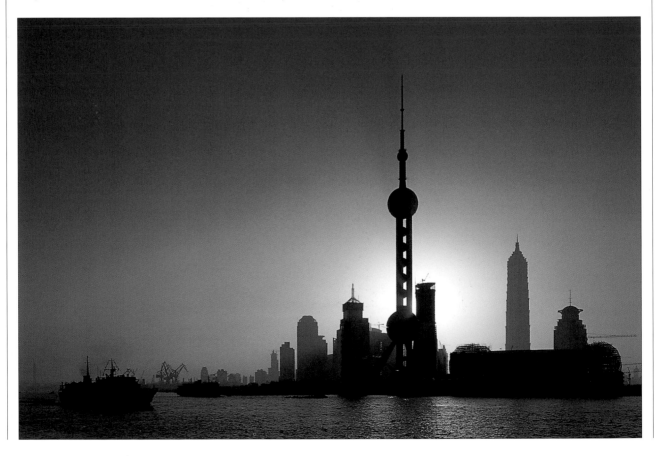

For dawn photography, you need to be in position at first light. That means that you should make a recce the day before as you'll have to travel there in the dark. The shooting experience is rather different from that at sunset—as the light increases, the possibilities of the view reveal themselves slowly. However, because the eye is already well adapted to the darkness, you'll find that the light levels appear much higher than they really are. If there is any movement in the scene that needs a reasonable shutter speed, you may have to wait longer than you expect in order to be able to shoot.

White-balance caution

If you are in the habit of shooting with the white balance set to Auto, this will overcompensate for the warmer colors from a low sun, and can produce a disappointing lack of richness to the image. The sunlight setting, which is balanced for 5400–5500K, will give a truer rendering of the color.

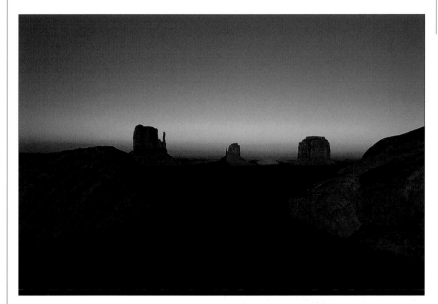

◄ Warm, rich color
Exceptionally clear air keeps the sun bright even when it is on the horizon and at its reddest, as in this shot of Monument Valley, Utah/Arizona. The strongest colors appear with the sun behind you and the camera. You can avoid the problem of showing your own shadow by positioning yourself so that it falls in the distance, as here, and not on foreground features.

▲ ► Watch the white balance
Make sure that the camera's white balance is set so that it does *not* compensate for the warm tones of a low sun, or the image will look strangely *un*sunset-like. This happened with an Auto setting (above), in contrast to a straightforward Direct Sun setting (right).

Case study: **tropical sunrise**

Fishing boats, palm trees, and a river at dawn offered the ingredients for a memorable tropical landscape photograph—and maybe more.

The river mouth in this sequence of images, on the Malay Peninsula, had a convenient camera position: the bridge across the river. I checked out the view the afternoon before, and was in position by 5am the following morning, with the camera on a tripod. Sunrise in the tropics is close to 6am, and the sun moves very rapidly, so the time I had available for shooting was relatively short—about an hour, from about 45 minutes before sunrise to about 20 minutes after.

As the light changed, I had to respond by altering the framing, the focal length, the format, and even the viewpoint, to a limited extent. The first essential was to find a good basic camera position that gave a comprehensive view of this potentially attractive scene. The only way to do this was to research the location during the day. I say "potentially attractive" because one of the lessons to be learned here is just how different a scene can look between a visit at midday and at the actual time of shooting. You can't expect to predict exactly how the scene will look, so there is always an element of chance. As it happened, this was one of the successful occasions.

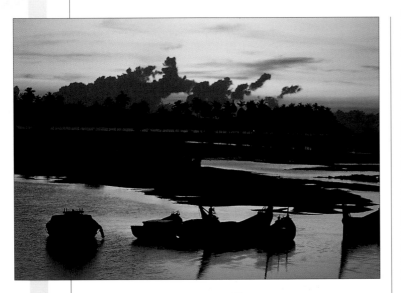

5:30am
With 45 minutes to go before sunrise, the low light levels needed 1/2 second at full aperture, causing some slight blurring to the water ripples.

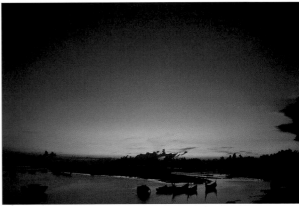

5:35am
The range of colors in the sky, from deep blue to orange, was at its greatest in a wide-angle shot, because it took in such a broad view of the sky, from the orange close to the horizon to the deep blue above.

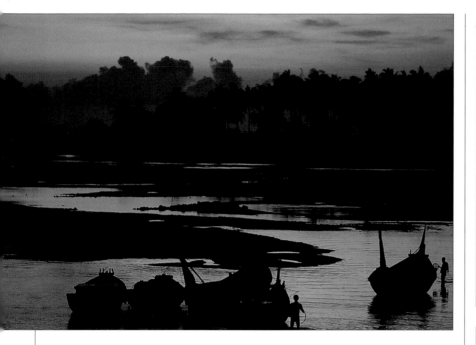

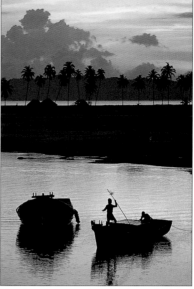

6:05am

25 minutes after the previous shot, the light levels had risen sufficiently for a shutter speed of 1/60 second—enough to freeze normal movement among the fishermen.

5:40am

One problem with the magnified view from a telephoto was the movement of fishermen and boats; only now, about 20 minutes before sunrise, was there enough light for a shutter speed to freeze most of it, at 1/15 second.

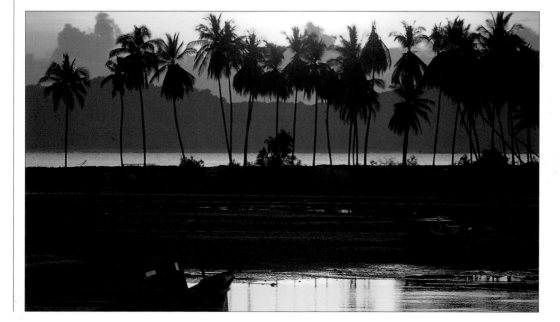

6:15am

About 15 minutes after sunrise, the sun broke through the low line of clouds. Immediately the contrast rose rapidly and there were no more worthwhile photographs after this shot. Already the sun and its reflections are showing signs of overexposure. Although the whole session had lasted no more than an hour, it had embraced a wide variety of lighting effects.

Case study: **critical timing**

There are many times, particularly in landscape photography, when the shot can be anticipated and the camera set up in advance, and what remains is to judge the best time to shoot—but things don't always go according to plan.

Some scenes are worth taking trouble over with the light. Getting the light just right is often a matter of precise timing. If you restrict the project to clear weather, the question of the timing becomes simpler—although it is by no means predictable.

First find a landscape location with a reasonably definite subject. Select the viewpoint, and decide what the preferred angle of the sun should be. In this example, the subject is Delicate Arch in Utah, and the view one that shows the arch clearly with illumination that varies during the afternoon, from side lighting to nearly frontal. The potential for a rich color to the rock was an important factor in my decision to shoot late in the afternoon, just before sunset, as was the possibility of interesting shadows.

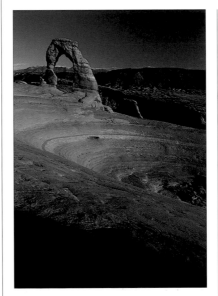

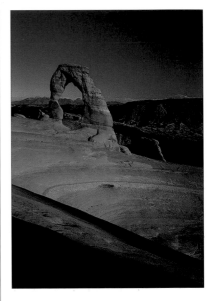

1 This is the first view from the trail of the dramatic arch of rock and its setting. Using a wide-angle lens (20mm equivalent), I took the photograph about two hours before sunset. It works well like this, but in preparation for what I confidently expected to be a rich sunset, I decided to change the camera position. The reason for doing this was that the arch is situated on the edge of a rock bowl, and with the late afternoon sun setting over my right shoulder, the foreground shadow that can be seen here would later creep forward. As a result, just before sunset, when the color would be at its best, the bowl would be completely shadowed, thus becoming a large irrelevance in the composition. For this reason, I moved the camera closer to the arch, near the top left of this view.

2 In the new position, an hour before sunset, I used the same wide-angle lens. The camera was set back from the bowl's lip, and a small band of foreground shadow lent weight to the lower part of the shot. With the sun lower, the texture of the rock became more interesting. This shot was timed so that the small circular depression was just distinct on the edge of the main shadow. Any later, and the dense shadow would have been too dominant.

3 I still wanted the richer colors close to sunset, so I moved forward again. The middle distance and beyond were under control, and the variable was still the foreground shadow. Since the rocks behind might have broken the shadow's pattern as the sun sank, I set the camera up in this position. The shadow had reached the ledge just in front of the camera and briefly there was a double shadow line, as I had hoped.

What I expected was that the intensity of color would increase until shortly before the sun touched the horizon; around this point atmospheric effects would dim the light. I didn't know exactly how the shadows would fall across the scene. In principle, they would creep forward, but I could only guess at their positions and shapes. In this kind of situation, you have to shoot at regular intervals as you wait, in case the best moment passes without your realizing in time.

As it turned out, there were two best moments for shooting. The first was when the shadow lines gave the clearest view of the curving sweep of rock below the arch. The second was that of the reddest light, just before the intensity of the sunlight began to weaken. A very low sun and the warm-toned sandstone combined to give an unusually intense color.

Shadow path

In the last hour or so of the afternoon, the sun's path across and down caused the shadows in the picture area to move as shown in the diagram. These shadows were cast by rocks behind and to the right of the camera, and for the timing of the photographs there were two important breaks in the shadows' direction. The first was caused by the ledge in front of the camera making a break in the shadows. The second was the point at which they began to rise up the arch.

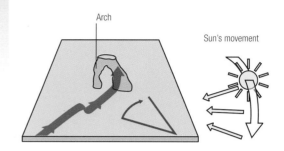

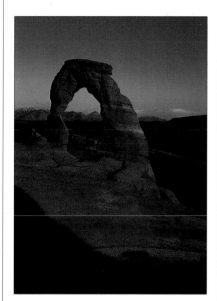

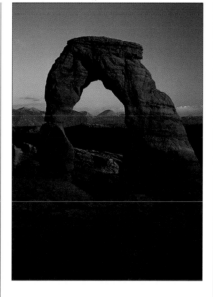

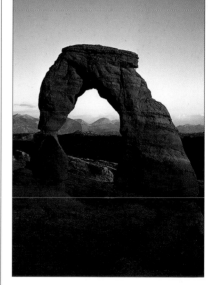

4 With the bowl now rapidly being filled with intense shadow, I changed to a standard focal length (50mm equivalent), concentrating solely on the arch. The aim was that the intensifying color would carry the shot, but with the view framed like this I realized that the image design was not particularly interesting.

5 I moved the camera a little further back, to keep some of the bowl's sweep. This, my second principal shot, was timed, like the others, for the exact position of the shadow line. The lower shadow, balancing the dark hills beyond, made it possible to frame the arch off-center.

6 Within seconds, the loss of direct sunlight became obvious below the arch. The moment for shooting had already passed.

Twilight

With the sun below the horizon, it is the afterglow that lights the scene, often with a surprising delicacy not found under any other conditions.

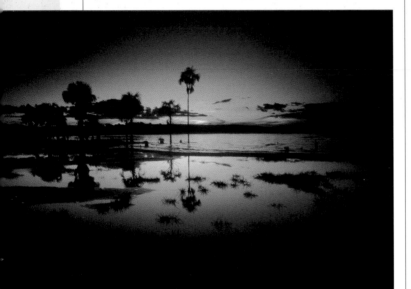

Like normal daytime skylight, twilight is a reflected light source, but is rather more complex in its effects. It is the light that appears a little before sunrise ("first light") and that remains for a short time once the sun has set. In a clear sky, the intensity shades smoothly upward from the horizon, where it's brightest, and outward from the direction of the sun. (The studio equivalent is a light placed on the floor, aimed up toward a white wall, and used as backlighting.) The sky, in fact, acts partly as a diffuser and partly as a reflector. The actual light levels vary considerably from a just-discernible glow to actual sunset or sunrise.

These conditions offer a fairly wide choice of exposure. If you are shooting directly toward the twilight, you can try a short exposure in order to make a silhouette of the horizon and subject. In this kind of backlit shot (the photograph above right is a good example), the shading of the sky from bright to dark gives some choice of exposure, particularly if you use a wide-angle lens. Less exposure intensifies the color and concentrates the view close to the horizon. More exposure dilutes the color in the lower part of the sky, but shows more of the higher, bluer parts. In other words, increasing the exposure extends the area of the subject within the frame. A range of exposures is acceptable, depending on what kind of effect you are trying to achieve from the photograph.

Not only does the brightness shade upward from the horizon, but the color does also. The exact colors depend on local atmospheric conditions, and the different light-scattering effects described on pages 38-39 are combined in a twilight sky. At a distance from the brightest area—opposite and above—the color temperature is high, as it would be during the day. Close to the horizon in the direction of the light, however, the scattering creates the warmer colors at the lower end of the color temperature range: yellow, orange, and red. These merge in a graded scale of color.

Reflections at dusk

Shooting from almost at water-level enhances the delicate tonal gradation before night falls over the Guiana Highlands of Venezuela. What makes this view attractive is that almost all the color has been drained from the scene.

Lens focal length

Experiment with both wide-angle and telephoto lenses, or both ends of the zoom range. Wide-angle views take in more of the height of the sky and capture a wide range of color. Telephoto shots, with a narrower angle of view, can take in only a small part of this; perhaps only a single color.

Smooth reflected light

The gradual shading of light and color can be very valuable when shooting a subject with a highly reflective surface. At the right angle, twilight produces a broad reflection without distinct edges, and this can make simple and attractive illumination for reflected objects, such as a car. Experiment with the height and camera angle to get the maximum reflection of the sky.

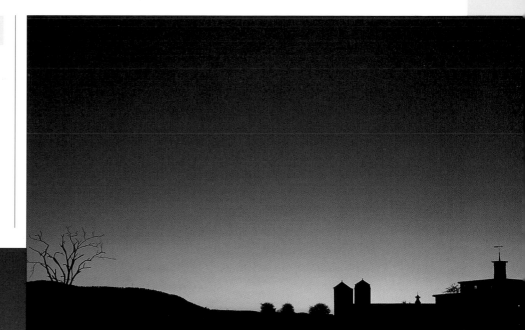

◀ Blue intensity

When the sky is not red or orange at sunset or sunrise, an overall blue cast is typical, as in this winter scene.

▲ Shading of the sky

A clear sky at dusk or dawn acts like a smooth reflective surface for the sun as it lies below the horizon. The light shades smoothly upward from the horizon, and this effect is most obvious with a wide-angle lens, which takes in a greater span of sky. For example, while a 180mm telephoto lens gives a limited angle of view of only 11 degrees, a 20mm wide-angle gives an angle of view of 84 degrees.

Clouds at twilight

Added to the basic lighting condition, clouds are fairly unpredictable in their effect. If continuous, they usually destroy any sense of twilight, but if broken, they reflect light dramatically: high orange and red clouds create the classic "postcard" sunset. The tropical sunrise sequence on pages 64–65 includes twilight, and one of the things that becomes clear after a number of occasions is that clouds at this time of day often produce surprises. The upward angle of the sunlight from below the horizon is acute to the layers of clouds, so that small movements have obvious effects. On some occasions, the color of clouds after sunset simply fades; on others, it can suddenly spring to life again for a few moments—a good argument for not packing up as soon as the sun has set.

Moonlight

The moon simply reflects sunlight, but very weakly. Capturing a scene by moonlight means allowing for the way we perceive it, as dark, colorless, and mysterious.

Photographing by moonlight needs long exposures, even at a high-sensitivity setting, as the intensity is in the region of 19 stops less than daylight. Such shots are generally worth attempting only around the time of a full moon, with clear skies.

A bright full moon is about 400,000 times less bright than the sun. Start with a setting of about one minute at f2.8 at ISO 200, and check the result in the LCD display.

Such long exposures make it tempting to switch to a higher sensitivity, but this increases the noise in the image and, as you will need to use a tripod in any case, it may be better just to make a longer exposure at the standard setting. Two other factors come into play. One is that we see moonlight as dim, and to reproduce that impression you should keep the exposure at least an f-stop or two less than normal. The other is that our night vision lacks color sensitivity, whereas the camera's sensor will pick up color as normal. Consider desaturating the image, or increasing the blue, for final display.

To photograph the moon itself you will need a telephoto lens of at least 400mm equivalent to make a reasonable-size image. The brightness depends on atmospheric conditions and on the phase. A bright, full moon needs an exposure at ISO 200 of about 1/250 second at around f8, but check in the LCD screen. Other phases of the moon and hazier conditions need longer exposures. Apart from the need to avoid camera shake, keep the exposure short because the rotation of the earth causes the moon's image to move across the frame. You will usually need to reframe each shot.

Shutter speed

For the moon to be a reasonable size in the frame, a powerful telephoto is needed, and as the maximum aperture of the lens is likely to be small, bracketing usually has to be done by altering the shutter speed. The limit to the slowest shutter speed is the movement of the moon's image in its orbit around the earth. The moon's image moves at a rate of its own diameter every two minutes. For a 400mm-equivalent lens, an exposure of one second or longer will cause blurring.

The moon itself

Photographed with a 600mm lens on a Nikon D1 (an efl of 900mm), the gibbous moon almost fills the frame, with good detail. I made three exposures at the full aperture of f4, at 1/80, 1/100, and 1/125 second. This is the second. Even at these shutter speeds, camera shake is likely at this magnification.

By moonlight

The uncertainties of shooting by moonlight on film have all disappeared with digital. An adequate exposure is guaranteed by being able to check the results on the LCD screen, and shutter speeds rarely need to be so long that stars turn from points into streaks. Instead, the greater problem is preventing the image from looking like a daytime shot. Here, illuminated by a full moon in a clear sky, this Meroitic pyramid in the Sudan was first shot with Automatic exposure, which gave 10 seconds at ƒ2.8 at ISO 1600. The only small clue that this is not daylight is that there are a few stars. For the more succesful version, I gave a shorter manual exposure (6 seconds at ƒ2.8 and at ISO 1000), and asked a friend to trigger a small flash unit inside the entrance.

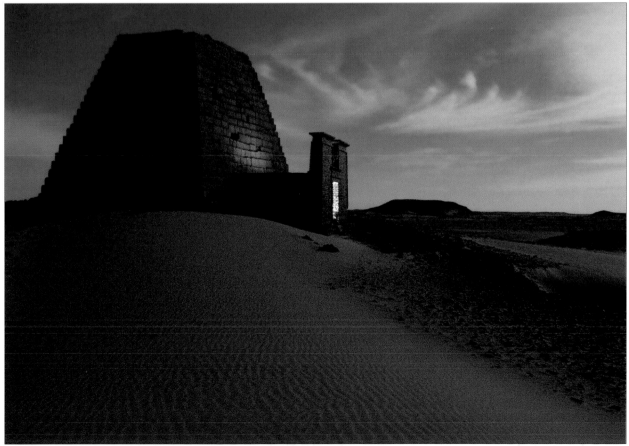

Cloud cover

Clouds are the most visible component of weather, and in outdoor photography they are by far the most important controlling factors in daylight, creating an enormous variety of effects.

Clouds diffuse daylight, softening scenes and reducing shadows. To make a comparison with a studio, they act as variable diffusers and as reflectors at the same time. Depending on their thickness, texture, extent, height, how they are arranged in layers, and their movement at different speeds, the permutations of cloudy conditions are infinite. The simplest situation is when the cloud cover is continuous. Overcast skies just diffuse the light, and if they are sufficiently dense that there is no patch of brightness to show the position of the sun, the light is as soft and shadowless as it ever can be. The table on light levels on page 85 gives an idea of how an overcast sky affects exposure.

Medium-to-heavy overcast skies have a reputation for bringing dullness to a scene, and to an extent this is true. Light comes more or less evenly from the entire sky, so the only shadows are those caused by objects being close to each other; this lack of shadow reduces modeling, perspective, and texture. Objects appear to have less substantial form, and large-scale views appear flat. There is virtually no modulation of light, and the even illumination in all directions makes conditions less interesting, with none of the lighting surprises that occur when shooting in changing weather.

The value of shadowless, overcast lighting is in its efficiency rather than in its evocative qualities. It helps to clarify images. Much depends on what you see as the purpose of the shot. If the photograph has to remain faithful to the physical, plastic qualities of the subject, then this even lighting may be valuable. Clarity in the image takes precedence over more expressive qualities.

Pastel greens

Soft, shadowless light and a delicacy of color characterize landscapes under the diffuse light of continuous cloud.

Image clarity

Overcast skies are good for certain subjects, particularly those with intricate shapes. The chief characteristic of this kind of lighting is that it is clear and uncomplicated. Hence it is good for giving distinct, legible images of complex subjects. Reflective surfaces also make for more legible images under diffuse lighting: the reflection of a broad, even light source will cover all or most of any shiny surface. By contrast, in clear weather, the sun appears as a small, bright, specular reflection.

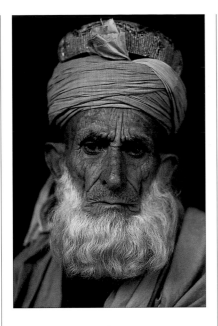

Portrait lighting

One of cloudy light's better qualities is that it does away with harsh shadows, making it useful for portraits.

A tinge of blue

The effect on color temperature is most obvious when clouds pass across the sun, as in these two images of a peacock. Use the camera's Cloudy white-balance setting, which will compensate.

Clouds and color temperature

Clouds affect color temperature by changing the relative strengths of sunlight and skylight. On a clear day (1), even though the sky is blue, the sun is so much stronger that it overwhelms the higher color temperature from the rest of the sky; only the shade, typically 3 or 4 stops darker, is bluish. When scattered clouds cross in front of the sun (2), they reduce its strength, leaving the blue skylight relatively more important. When the entire sky is cloudy (3), the color temperatures of the two light sources, sun and skylight, are thoroughly mixed; as a result, the color temperature of the diffuse light reaching the ground is raised slightly overall.

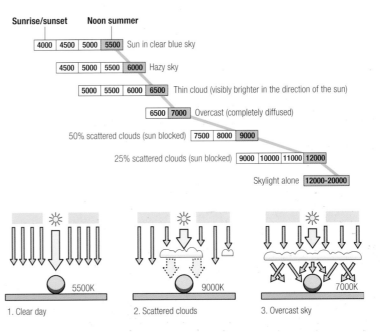

Sunrise/sunset Noon summer

| 4000 | 4500 | 5000 | 5500 | Sun in clear blue sky

 4500 | 5000 | 5500 | 6000 | Hazy sky

 5000 | 5500 | 6000 | 6500 | Thin cloud (visibly brighter in the direction of the sun)

 6500 | 7000 | Overcast (completely diffused)

50% scattered clouds (sun blocked) | 7500 | 8000 | 9000 |

25% scattered clouds (sun blocked) | 9000 | 10000 | 11000 | 12000 |

Skylight alone | 12000-20000 |

5500K
1. Clear day

9000K
2. Scattered clouds

7000K
3. Overcast sky

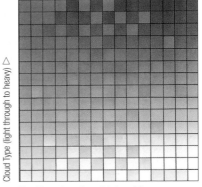

Cloud Type (light through to heavy) △

Cloud Cover (none through to heavy) ▷

This chart plots brightness of clouds (which depends on how thick they are) against the degree of cloud cover.

The variety of clouds

Clouds of different kinds, layers, and thicknesses create a complex, endlessly changing arena of light.

Lighting conditions are more complicated and less easy to anticipate when clouds are broken, so that there is a mixture with blue sky. In fact, the complexity extends to situations where there is more than one layer of broken cloud, each different in type. The diagram on page 85 gives an impression of the range of possibilities; even simplified like this, it shows how the intensity, quality, and color of light can vary. On a windy day, these conditions change rapidly, not only from cloud to direct sun, but from one type of weather to another. Watch what happens when a cold front passes over. Between scattered and partial cloud cover, the most noticeable effect is the fluctuation of the light; at the left and right of the scale, conditions are most consistent.

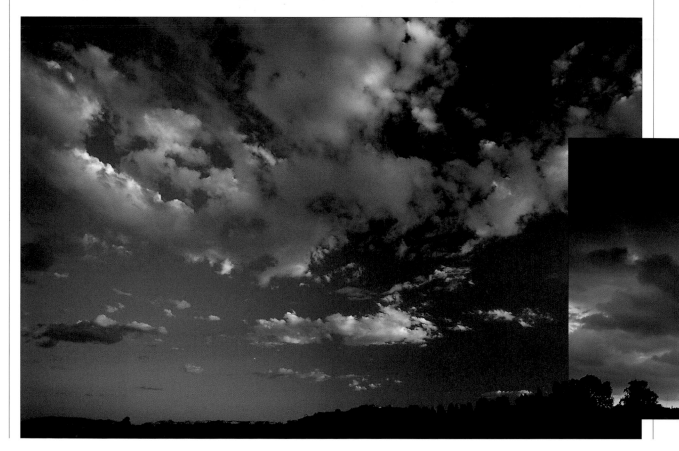

If you are trying to take a particular shot that you have fixed in your mind, scattered cloud on a windy day can be frustrating, to say the least. The light changes up and down, delaying the shooting. However, the sheer variability of broken cloud can produce some of the most interesting, and even dramatic, lighting. To take advantage of it, however, you need to react quite quickly. Familiarity with the different light levels in any one situation will help; if you have already measured the difference between cloud and sunlight, you can change from the one setting to the other without having to use the meter again. Under heavy cloud with a few gaps, this may be particularly useful, as the sunlight is likely to move in patches across the landscape and be difficult to measure quickly.

Distinct clouds

Some idea of the visual complexity of distinctly shaped clouds is given by the chart below, which plots the brightness of individual clouds—mainly a matter of how thick they are—against the degree of cloud cover. The less cloud cover, the more the blue of the sky has an effect.

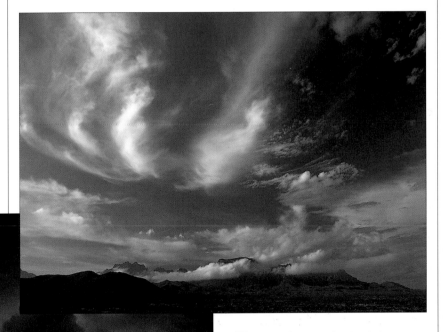

▲ Clouds as subjects

These three photographs are just a small sample of the great variety of cloud formations, and illustrate the very different effects that they can have on a picture. The shot above shows scattered cloud cover in fading light with good visibility; the shot at left reveals watery sunlight filtered attractively through low, dark storm clouds; and the photograph far left illustrates puffy rain-shower cumulus in a bright sky.

▲ Light and shade

Clouds passing over a landscape create a kind of chiaroscuro (light and shade) effect. This tonal overlay is seen to its best advantage at a distance and from a high viewpoint, as in this aerial view of a southern Philippine port.

Bright cloudy skies

Unless the sky is a rich, deep blue, the contrast between it and the ground is likely to be very high, to the point where it appears washed out.

In landscapes and other views that include the horizon, a 100% cloud cover alters the tonal relationship between sky and land. Without cloud, the difference in brightness between the two is usually fairly small; quite often, the subjects are lighter in tone. This is not the situation when cloud extends all over the scene. Then the cloud cover is the light source and, if you include it in the view, you will have a contrast problem. In other words, if the scene includes the horizon, you will inevitably lose detail either in the sky or in the ground. If the subjects or the ground are properly exposed, the sky will be white, without any visible texture to the clouds.

Many photographers simply avoid including the horizon and sky in a shot under these conditions, but you may occasionally find that you have no choice. One answer during shooting is to use a neutral graduated filter over the lens, aligning the soft edge of the filter's darkened area with the horizon line, so that the sky is made darker.

There is also a purely digital answer, which works best if you use a tripod and can keep the framing perfectly steady. Make two exposures, one good for the subjects on the ground, the other good for the sky (dark enough to show cloud texture). Later, in an image-editing program, the ground from one and sky from the other can be combined to get the best of both worlds.

Neutral graduated filters

Although skies can be darkened later during image editing, a grad filter at the time of shooting preserves more sky detail. Neutral grads are available in different strengths—here ND0.3 darkens by 1 f-stop and ND0.6 by 2 f-stops. Two grads can also be used to reinforce each other or, with one inverted, to focus attention on the horizon.

Grad filter 1

Grad filter 2

2 Grads filter

Inverted Grads filter

Combining two exposures

In this Icelandic landscape, a normal exposure for the valley leaves the clouds overexposed. Taking a second, darker exposure with the camera on a tripod, so that the images are in perfect register, makes it easy to combine the valley tones from one with the deeper sky tones from the other. In Photoshop, the "valley-normal" shot is placed in a layer over the darker version, and with a large-diameter eraser brush the over-bright sky area in the upper layer is gently removed.

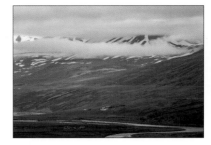
Normal exposure

Exposure for clouds

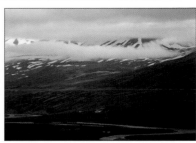

Combining layers
The normal shot sits on the top layer, above the shot that has been exposed for the cloud cover. If the top half of the normal layer is erased with a soft-edged brush, the cloud layer shows through.

Curves
To make the most of the color tones in the image, a slight adjustment is made using the Curves command.

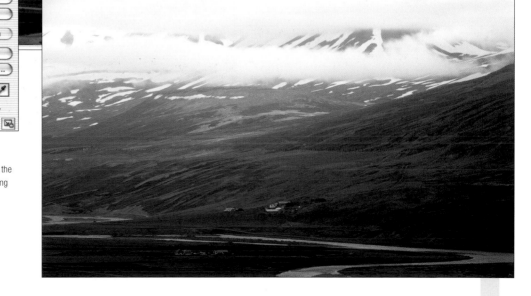

Rain and storms

Wet and stormy weather tends to discourage photographers from going out, but it offers a range of interesting conditions, from glistening surfaces to flashes of lightning.

Rain may be uncomfortable, and digital cameras, with all their circuitry, certainly need good protection from rainwater, but in terms of lighting rain makes a relief from standard sunlight. Light levels are typically low because of the thickness of most rain clouds, but the gentle, shadowless, and enveloping light is good for capturing the purity of natural colors in landscapes. Greens in particular come out well on wet days, so this can be the ideal time for garden and woodland scenes.

Photographing rain itself is not easy, because of the poor light and the speed at which raindrops fall. Often, rain looks like mist in many photographs, or, if heavy, as lines. To capture actual raindrops, the best conditions are back-lighting against a dark background, which is uncommon in rainy weather. The best sense of raininess often comes from the subjects—such as drops on leaves and car windscreens—rather than from the light itself. The levels are usually very low: rain and cloud together easily reduce the light by 4 or 5 stops.

Lightning can add considerably to the power of a landscape. The problem is predicting it—the exact moment and also the direction. There is no way of synchronizing lightning flashes with the shutter, and the only certain technique is to leave the shutter open in anticipation of a strike. Fortunately, the electrical conditions that produce one lightning flash usually produce a number, often more or less in the same place. At the height of a storm, you should not have to wait more than 10 or 20 seconds for the next flash, and it is more likely to be in the direction of the last few flashes than in any other. Nevertheless, lightning in daylight is difficult to shoot without overexposure. If there is still light in the sky, estimate the average interval between flashes, and set the camera to allow a time exposure longer than that.

Ordinarily, the exposure depends on the intensity of the individual flash, whether it is reflected from surrounding clouds and how far away it is. You can estimate the last, at least through a group of flashes: count the number of seconds between seeing the flash and hearing the accompanying thunder. The difference is the speed of sound; a gap of five seconds means that the lightning is 1 mile/1.6km away. Check your first exposure on the LCD screen, and adjust the aperture as necessary.

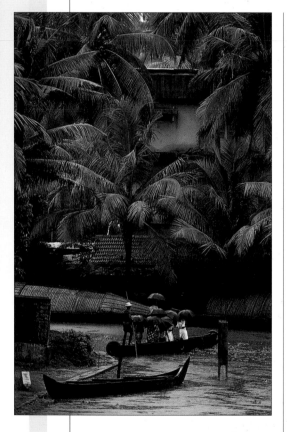

Monsoon haze

In this shot of a typical south Indian day during the monsoon, the rain is heavy yet appears like a dull haze. However, the people sheltering beneath umbrellas underline the reality of a rainstorm.

▶ Impression

Sometimes the most effective image of a storm relies on minimal detail, as in this view of swirling mist and driving rain on a mountain in Central America.

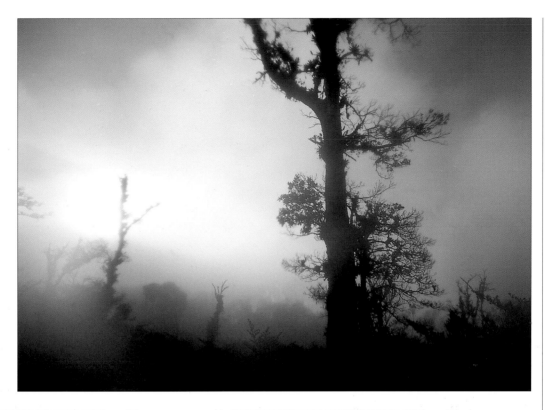

◀ Capturing lightning

Distant lightning over Rangoon was shot at dusk with a 30-second exposure—long enough to catch a few cloud-to-cloud strikes and one cloud-to-ground strike. The aperture was f2.8 and the sensitivity ISO 100.

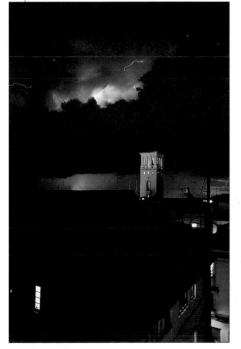

◀ Rain effects

To establish "raininess," some visual clues can help if you include them deliberately. In this shot, the reflections of car headlights in the wet surface of a Toronto freeway make the point effectively.

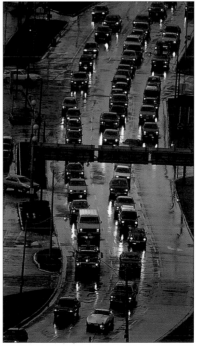

Post-production color

Although the best time to adjust color and tone is when you shoot, image-editing programs on the computer offer you an impressive degree of control over the final image.

As your experience with your camera's white-balance controls and LCD display increases, your color accuracy will improve. However, viewing the images on a computer later, you may find that the colors need adjusting. This may be in the interests of accuracy, or to suit your personal taste. The software supplied with the camera offers some measure of control; Photoshop or a similar application offers even more; and specialized software can tackle specific color problems.

Color changes can be global, affecting the entire image, or selective. For overall adjustment, first see what tools the camera manufacturer provides. If you are shooting in a RAW format—the manufacturer's proprietary mode—there may be a quality advantage in using the tone and color editing tools supplied, because the image settings and data settings are usually kept separate. Photoshop has more sophisticated tools, such as Curves and HSB sliders, which let you pinpoint certain hues, tones, or other qualities such as saturation. Another way of isolating your changes is selection—delimiting an area of the image, such as the sky. Once it has been selected, you can lighten, darken, or make other changes just to this area. Reversing the selection enables changes to be made just to the remaining area.

12-bit whenever possible

Top-of-the-line digital cameras have sensors that can capture 10 or 12 bits of color instead of the standard 8 per channel, as we saw on page 15. They also let you save images in RAW format rather than the usual choices of TIFF or JPEG, and this preserves the extra bit-depth. If you expect to adjust the color on the computer, you should use this option: the many more steps in the color gradient make for a smoother adjustment, less damage to the image, and less risk of banding. As an experiment, take two identical images, one 8-bit and the other 10- or 12-bit. Photoshop will take in the 12-bit image as 16-bit. Make identical adjustments to each (in this example, Curves followed by Saturation adjustment for the green leaves). Then compare the resulting histograms (Levels in Photoshop). Spikes in the 8-bit version reveal the damage that is avoided in 16-bit editing.

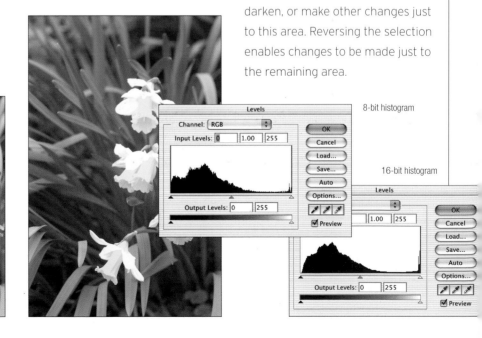

8-bit histogram

16-bit histogram

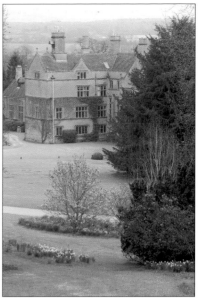

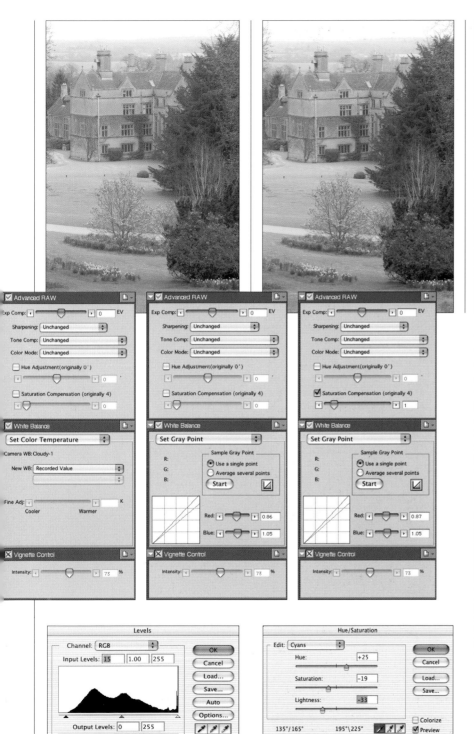

Two-stage correction

With this shot taken in RAW format (Nikon NEF), the first choice of editor is the camera manufacturer's own (Nikon Editor). The separation of data from settings in this format makes it possible to revisit the scene. In this case, I felt the original color temperature setting had over-compensated for the cloudy weather, and used the Gray Point control to sample the roof slates and use those as neutral gray. I also enhanced the saturation. Later still, in Photoshop, I took care of the last remaining problem: the cyan shift in the distant parts of the landscape beyond the house.

Photo-specific software

A number of software developers sell effects suites or individual filters specifically to adjust photographs. Most of these work through major applications such as Photoshop. Once installed as plug-ins, you can access them through the Filter menu in Photoshop. German company nik Multimedia, for example, specializes in alterations to photographs, which have different characteristics from the ordinary run of computer graphics— more random detail, subtlety of color and tone, and fewer precise edges.

Digital effects

Many of the conditions of natural light
and atmosphere can be worked on very
effectively on the computer; they can be
modified and even, at times,
created from scratch.

There are no limits to the amount of
adjustment and alteration that can be made
digitally to images, but here I will confine myself to those
that have an effect on natural light. The most obvious of
these digital techniques are those applied to the sky.
Two of them, gradation and polarization, mimic the
effects of filters that are normally used in front of the
lens. Another makes use of a perceptual effect to turn
fine weather into a threatening storm.

Close to the ground, atmospheric haze, mist, and even fog can be poured
into a scene, though to be effective the technique calls for a hands-on
alteration to detail. These atmospheric conditions are readily imitated by
placing a pale gray layer over the image at some degree of opacity, but the
skill comes in thickening this with distance from the camera. The usual
method is first to create a depth map, tailored to the particular image. These
are just some of the possibilities, and if you are inventive—and can spare the
time and effort—there are endless ways of tweaking the light. In addition,
on the following pages we look at the more complex issue of actually
introducing light into the scene.

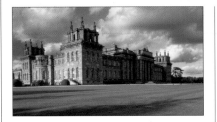

The gathering storm
Dark skies, indicators of a looming storm, can
dramatize a landscape, particularly if combined with
sunlight. However, if the sky is blue, this will simply look
unrealistic. The trick is to desaturate the sky, turning the
clear blue areas into what appear to be thick altostratus
cloud. Then apply darkening and stronger contrast to
taste. In this example, the sky was first selected with an
auto selection tool (complete edge accuracy is not so
important here, as the main alteration will just be
desaturation). The blue sky was selected with the dropper,
in order to leave subtle cloud colors relatively unaffected,
and then desaturated, darkening slightly. Then, the entire
sky was lowered in contrast, using Curves for realism.

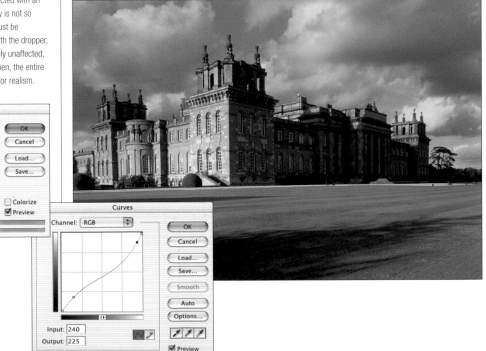

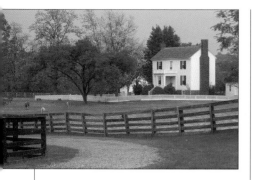

Digital atmosphere

Adding fog or mist to an image digitally is a hands-on procedure, as it requires objects at different distances from the camera to be isolated and masked. This is impossible to automate.

Save Selection

Destination
Document: 9547.21 Farm, Lync...
Channel: New
Name: fog

Operation
⦿ New Channel
○ Add to Channel
○ Subtract from Channel
○ Intersect with Channel

OK
Cancel

Step 1

With this shot of a countryside scene near Lynchburg, Virginia, the basic means of applying fog was straightforward. First, a gradient ramp was created and saved as an alpha channel.

New Layer

Name: Color Fill 1
☐ Group With Previous Layer
Color: None
Mode: Normal Opacity: 100 %

OK
Cancel

Load Selection

Source
Document: 9547.21 Farm, Lynch...
Channel: fog
☑ Invert

Operation
⦿ New Selection
○ Add to Selection
○ Subtract from Selection
○ Intersect with Selection

OK
Cancel

Layers | Channels | Paths

Normal Opacity: 64%

Lock:

Color ...
Background copy
Background

Step 2

The alpha channel was loaded into a new layer and filled with gray at a 64 percent opacity.

Step 3

To make the effect realistic, the foreground and middle-ground fences had to be protected from this overall effect. They were each outlined with a path, which was then converted to a selection, and this was deleted from the main fog layer.

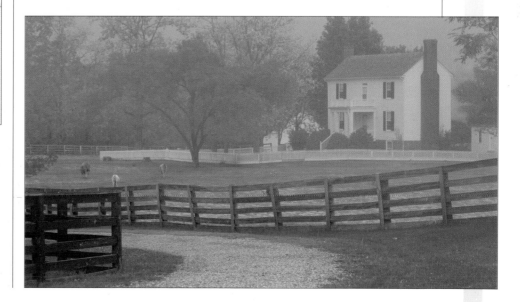

Brightening up

One of the special challenges in altering the appearance of light digitally is to create the effect of bright, sharp sunshine, but there is software available that will help.

One of the fundamental questions in image editing is how far you should go—that is, how far you should move away from the original as it was shot. We will keep returning to this theme throughout this series of books because there are no clear rules. In principle, anything and everything can be changed; in practice, it depends on what you personally feel is acceptable and on how much effort it is worth to you.

With daylight photography, the major hurdle is bringing sunshine into the picture. If you have ever waited for a break in the clouds to brighten up the scene, you will know that there is a demand for this—and to an extent this can be done digitally. The problem, as you can check by comparing two versions of the same view, overcast and sunny, is that direct sunlight affects everything and in many ways, down to tiny shadows and the glow reaching into shadows from sunlit surfaces.

I try to avoid discussing specific software programs, but in this case there is, to date, one specialist application that makes a passable job of adding sunshine to dull or hazy scenes: the appropriately named Sunshine filter in the nik Color Efex suite. It uses a series of complex light-casting algorithms at different contrasts as the starting point, with slider controls that enable you to adjust saturation, warming, intensity (brightness), and spillover of all these into adjacent areas. That done, if you want clearly defined shadows you will need to add them by hand—but it may be sufficient to create only a few large ones. Once the viewer has been given enough visual clues to believe that there is sunlight, detailed omissions tend to be ignored.

Another piece of light-bringing effects software is a flare filter, of which there are a number of makes,

Dull and overcast
The original scene, on a very English cloudy day. While this lighting works for some things—*see pages 72–73, for example*—it does no favors to a landscape like this that includes sky and water.

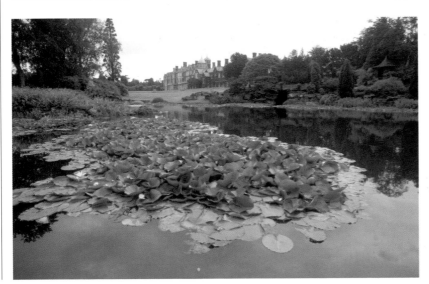

Light levels under cloud

Although clouds reduce brightness when they block the sun, the amount depends very much on the type of cloud. If the clouds are indistinct and spread across the sky, the light loss is on a simple scale from a light haze (as little as 1/2 a stop less than clear sunlight) through thin high stratus to dark gray, low clouds (up to 4 or 5 stops darker, and more in exceptionally bad weather). With distinct clouds, however, such as scattered fair-weather cumulus, the light levels can fluctuate rapidly, particularly on a windy day. Light, white clouds usually cause a simple fluctuation of about 2 stops as they pass in front of the sun from bright to shade in one step. Dark clouds with ragged edges, or two layers of moving clouds, cause more problems, as the light changes gradually and often unpredictably. In the first case, two light measurements are all that is necessary—one in sunlight, the other as a cloud passes—and once this is done, you can simply change the aperture from one to the other, without taking any more readings. In the case of more complex moving clouds, constant measurement is essential, unless you wait for clear breaks and use only these.

Light loss with evenly spread cloud cover							
	Clear sun	Light haze	Heavy haze	Thin high cloud	Cloudy bright	Moderately overcast	Heavily overcast
f-stops	0	-1/2	-	-1½	-2	-3	at least -4

including some supplied within Photoshop. These need to be applied with caution and only occasionally, due to general overuse. Even though optically accurate, they can, through overfamiliarity, easily look like what they are—computer-generated effects. At the right time and place, however, a touch of flare can help tip the balance in convincing the eye that there is sunlight where none existed.

▲ Sunshine
This filter in the nik Color Efex Pro suite uses a complex mix of procedures to simulate the effects of sunshine—except shadows, which need a human eye to interpret. In this case, the absence of relief in the foreground means that there would have been no prominent shadows in real sunshine.

Haze

Haze softens sunlight, weakens colors, and brings an extra sense of depth and perspective to a scene. Depending on what you want from a photograph, you might want to reduce haze or exploit its special qualities.

Haze is the scattering of light by particles in the atmosphere. Fine dust and pollution produce it, as does high humidity. Haze varies considerably, not only in density, but in the wavelengths that are affected. The finest particles scatter the short wavelengths more than most, and produce bluish ultraviolet views over a distance. The haze from humidity, on the other hand, has a neutral color effect, and looks white over a distance.

There are two main visible effects of haze. One is on the view itself; the other is on the quality of light. The effect on a landscape is to make it appear paler at a distance; this is progressive, so that contrast, color, and definition gradually drain away from the foreground to the horizon. This effect is strongest when the sun is in front of the camera (but not necessarily low), and is what contributes most to aerial perspective—the impression of depth due to the atmosphere. To make this work strongly, however, you would need to shoot in such a way that there are at least a few

▽ Depth and atmosphere
Haze adds a luminous, slightly mysterious quality to an image and brings a greater sense of depth and distance. In this photograph of a stone-capped burial tomb in coastal Wales, the haze, far from spoiling the shot, enhances the atmosphere of this ancient landscape.

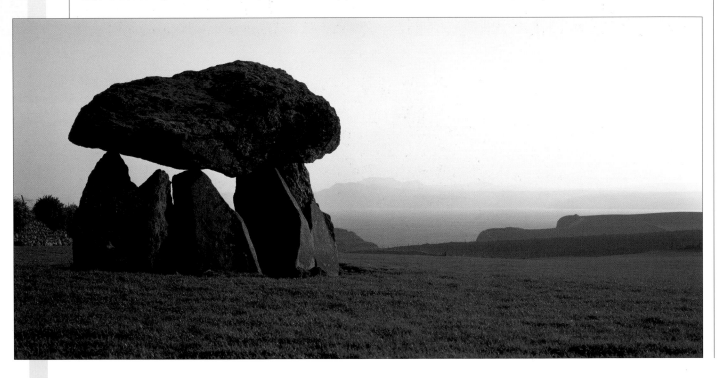

obvious planes of distance in the scene; simply photographing a long view, with no foreground or middle ground, will create a pale image.

The effect of haze on lighting is to soften the hard edges of sunlight. The extra scattering reduces contrast and helps to fill shadows. The effect can be an attractive balance between sunlight and diffusion, particularly when the sun is a little in front of the camera, as in the photograph on the opposite page. The amount of haze varies, as does its effects. Strong haze has much the same visible effect as light, continuous cloud.

Ways of reducing haze

Haze can be unwelcome if it hides detail, color, and crispness. The following are ways of reducing it:-

Ultraviolet filter This works on the short wavelengths only, so the effect is unlikely to be total. With black-and-white film, an orange or red filter has a stronger haze-cutting effect.

Polarizing filter This works most strongly at right angles to the sun (in side lighting) and gives an overall improvement.

Frontal or side lighting Either of these is preferable to back-lighting, which exaggerates haziness.

Avoid distant views The closer you shoot, the less atmosphere, and so the less haze. For this reason, a wide-angle lens may be an improvement over a telephoto.

Unfiltered

Ultraviolet filter

► Ultraviolet

In a distant view with a telephoto lens, as in this sequence shot in Canyonlands National Park, Utah, the ultraviolet effects are likely to be pronounced. You can make a substantial improvement in picture quality by using filters. In the unfiltered version (above) the haze appears as pale blue, and both contrast and color saturation have been weakened. Adding an ultraviolet filter (above right) improves the color contrast. Using a polarizing filter (right) has an even stronger effect.

Polarizing filter

Mist, fog, and dust

Thicker than haze, mist, fog, and dust tend to shroud scenes to hide all distant detail, but these conditions can also offer strange, evocative scenes.

Mist, fog, and dust can be so dense as to make even nearby objects difficult to see. The droplets or particles are so large that there is no selective scattering of wavelengths, just an overall diffusion. (Dust has its own color, and tinges the view yellow, light brown, or whatever.) Do not view these as problem conditions: they clear eventually—and when fog dissipates it often does so very quickly—and meanwhile can make interesting graphic images.

In dense fog, or when the sun is fairly high, there is little if any sense of direction to foggy light. If you choose the distance at which you shoot carefully and close to the limits of legibility, the color and tonal effect of the resulting pictures will be extremely delicate. Against the light, depending on the density, these conditions produce some form of silhouetting. Close to the camera, the subjects are likely to stand out quite clearly, with good contrast. At a distance, the silhouettes and setting will be in shades of gray. As the conditions shift, thicken, or clear, the nature of the images will change quite significantly. Dust in particular is a very active condition: it needs wind or movement to remain in the atmosphere. Backlighting gives the best impression of its swirling and rising, but then there are obvious dangers in using your equipment in such conditions.

Fog offers a wide range of opportunities. A valuable project on a foggy day is to restrict your shooting to one location, while trying to create as varied a selection of images as possible. As well as looking for different subjects and viewpoints and using lenses of different focal lengths, wait until the fog begins to clear to take advantage of the following shifting effects:

☐ delicate colors in directionless lighting

☐ depth of view with subjects at different distances from the camera, fading progressively toward the distance

☐ strong silhouettes against the light

☐ pale silhouettes

☐ clearing, shifting fog; a wide-angle lens is often best for showing different thicknesses of fog in one image

☐ a view from a high point of a sea of fog with clear air above, ideally with the tops of trees or buildings standing out.

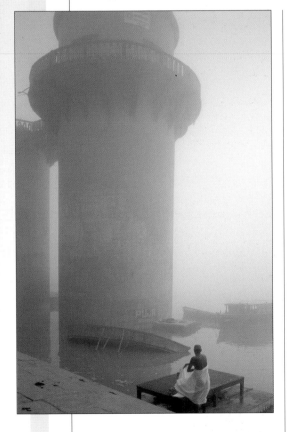

Shapes in the fog
In this early morning shot, fog over the River Ganges obscures the background and turns a large, not particularly attractive water tower into a soft, looming shape—a delicate counterpoint to the bather in the foreground.

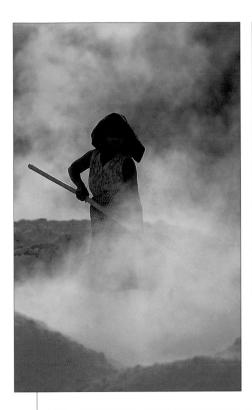

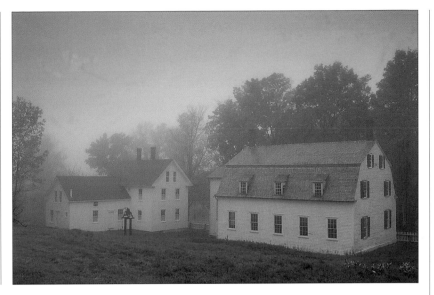

◀ Swirling dust

Although very damaging to cameras, dust can add considerable atmosphere to a picture. Here, swirling clouds of dust churned up by the earth-mover give the figure a looming presence. Backlighting from a setting sun makes the most of the subject.

▲ Receding pastels

Morning mist gives an overall softness to this shot of a Shaker village in Maine, USA, lending an attractive delicacy to the tones and colors.

◀ Ground mist

Another early morning condition is mist hugging the ground in a low layer. It rarely lasts long after sunrise, but when it happens it adds an ethereal quality to landscapes, giving the sense that taller features, such as buildings and trees, are floating.

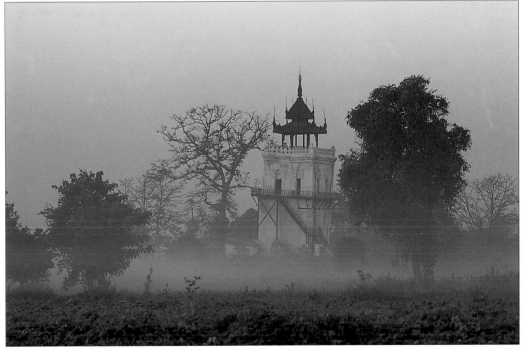

Snowscapes

Snow transforms landscapes, not only in appearance, but in brightness. The key tones in the scene, which it is essential to hold, are the subtle shades just below pure white.

A fresh fall of snow is the ultimate in bright surroundings. The studio equivalent would be an overhead light and a bright white curved base. When photographing local subjects in a snowscape, such as a portrait, the two most noticeable effects are powerful shadow-fill, particularly from beneath, and frequently bright backgrounds. The reflection that fills the shadows reduces contrast, which is no bad thing for many subjects under a direct sun. Bright backgrounds can create flare, and efficient lens shading is usually necessary. Landscapes and other overall views vary considerably with the quality of the daylight. Contrast is low under cloud, skylight, and twilight, but can be high in direct sunlight, particularly with backlighting.

Catching color and light

To borrow an analogy from photographic lighting, fresh snow is an almost perfect matt reflector. This means that it reflects sky colors intensely, as in this shot of a Japanese monastery in winter. The rising sun adds golden notes to the bluer shadows.

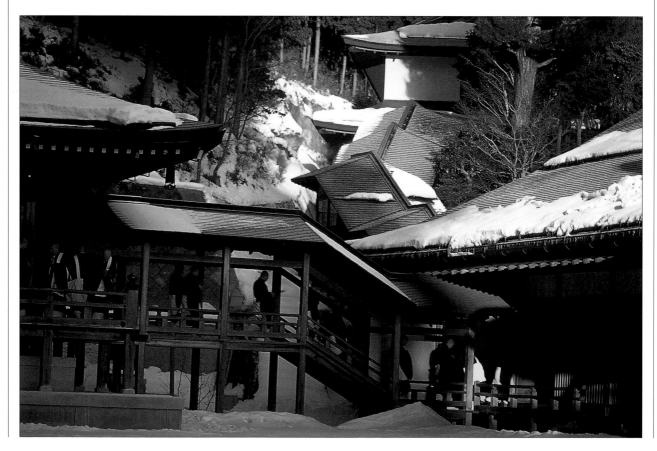

◀ **Monochrome under cloud**

In overcast weather, a layer of snow not only adds definition and contrast to what would otherwise be a dull, flat view; it turns the scene into near-monochrome. The effect, seen through sliding doors, is graphic and slightly removed from reality, as if an illustration.

Exposure becomes more critical in a snowscape than in most other landscapes, and once again the value of instant playback on the LCD screen proves the value of digital photography. Between a white that reproduces as a muddy light gray and one that is featureless and washed out, there is very little latitude in the exposure setting, and neither overexposure nor underexposure looks particularly good. The eye is quick to appreciate a pure white, and equally quick to discover when it seems wrong in appearance. The essential thing to remember is that if you take a direct reading of white, sunlit snow, you will need to add about 2 stops to the exposure. Even matrix metering, with its extensive database of different types of image, will have difficulty identifying a snowscape. As long as you remember this, there should be no serious problems, except that the final result will be delicate, and it is often wise to bracket exposures, if only by 1/2 a stop up and down.

▶ **Pale tones**
Also under a featureless, overcast sky, with no shadows, this Shaker village in Kentucky is rendered in a limited palette of off-whites. The subtlety is worth preserving; adjusting the image digitally for stronger contrast would probably be a mistake.

Light reflection

As snow is an efficient reflector, color or temperature differences in the sky are mirrored, and seem more prominent. Look, for instance, at the Andean photograph on page 45. In scenic views, this strength of color is by no means unpleasant, particularly if it is combined with other colors in the picture.

Case study: **Hadrian's Wall**

Partly because it reflects the light and the sky so well, snow provides an exceptional variety of images throughout the day, particularly in clear weather. This depends on the availability of a good covering of snow; something that may be certain in some locations but impossible in others. The ideal conditions are the day after a fresh snowfall, and clear, bright weather— time to drop everything else and spend the day out with the camera. Cloudy weather offers much less variety of lighting, and so of images. The example here was a winter's day in the north of England, on Hadrian's Wall, beginning at dawn and ending at sunset.

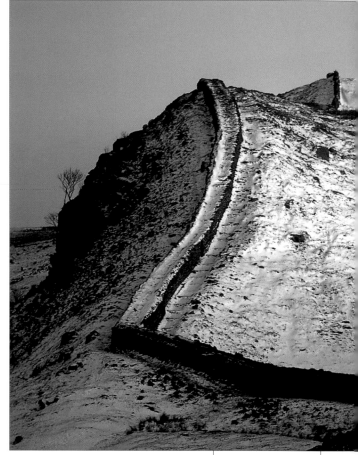

All of the photographs here were taken on a single day in one location, along Hadrian's Wall, the Roman fortification stretching across northern England almost from coast to coast. They are shown in the order in which they were taken. The first shot was taken just before sunrise, the last at sunset. Part of the exercise here was to capture as much visual variety as possible, including the changing lighting conditions during snowy weather and the reflective qualities of the snow. White snow picks up color readily, from the strong blue of a clear sky to the pinks and oranges of a low sun.

1 This was shot at dawn with a wide-angle lens (20mm equivalent) to cover the maximum amount of sky, shading from pink to blue.

2 A similar color range is reflected in the snow-covered ridge, shot at right angles to the sun with a telephoto (180mm equivalent) for contrast.

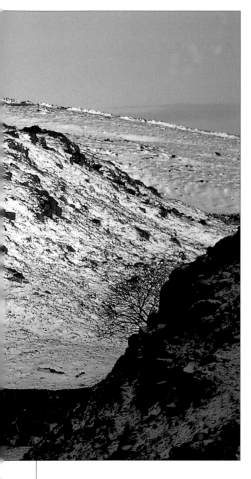

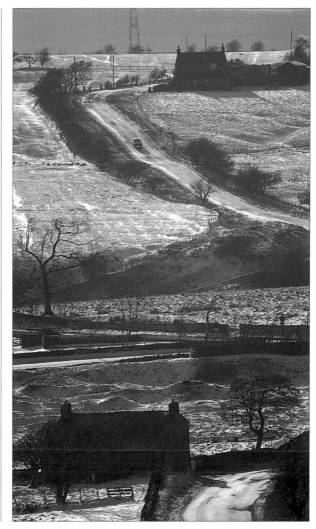

4 Here, a long telephoto (400mm equivalent) was used in the afternoon to compress the elements of a hillside.

5 This sunset provided a warm backlit shot that includes the sun.

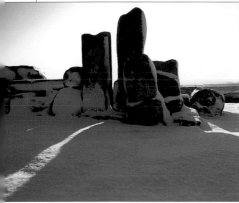

3 With the sun higher, the shadows are slightly less blue; a wide-angle view gave strong perspective. At the same time of day and with the same lens, aiming at the sun in 4 gives a high-contrast back-lit effect.

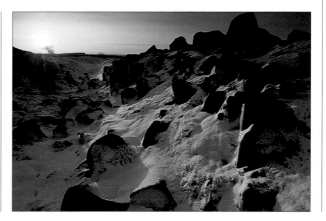

Mountain light

Mountains have a special effect on photography: the clearer, thinner air makes lighting starker and brighter, and the weather can change in an instant.

The sheer height of mountains helps to create some of their special conditions of light; their relief produces the others, through the frequently rapid changes that occur in localized weather. One of the most memorable weather conditions for photography is the clear, crisp air in sunlight, which gives high visibility to long views and fine detail. This, however, is only one of a variety of types of lighting found in mountains.

The air is thinner at altitude, and is therefore clearer, provided that the weather is fine. Since the air is thinner, there are fewer particles to scatter light into the shadow areas, which consequently can be very deep. Local contrast, as a result, is often very high. The skylight in shade is a more intense blue than at sea level. This intensity is more than usually difficult to

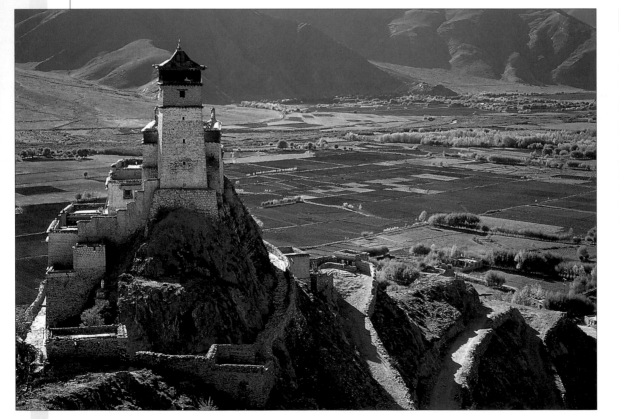

Clarity
At an altitude of 16,400ft (5000m), there is 50% of the oxygen that exists at sea level. For photography, this means an unusual sharpness and clarity. In sunny conditions, as on this Tibetan plateau, there is high contrast with deep shadows. If your camera offers tone or contrast compensation, you may need to make adjustments to lower it.

estimate and without correction can be stronger than you expect. The thin air is also a less effective screen against ultraviolet rays, and there is a higher component of these short wavelengths. This produces an unusually large difference between what you can see and what the camera's sensor will record. Unless you want to make use of the blue cast to emphasize distance, use strong ultraviolet filtration. Remember also that, in reacting to the ultraviolet wavelengths, the sensor receives more exposure, and the distant parts of the scene will look paler than they do to the eye.

So much for the thinner atmosphere. The interesting part of mountain light comes from the changeable weather, and this is controlled strongly by the relief of ridges and valleys. In particular, clouds become a part of the local lighting, as the case study on the following pages shows.

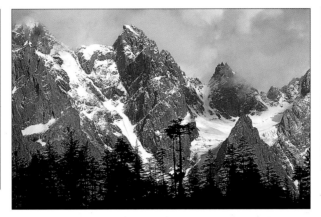

Islands in cloud

Among the more spectacular opportunities that high mountains offer is the chance to look down on the lower cloud levels. This is more typical of early mornings, as in this detail of the Sierra Nevada in Colombia.

Variable weather

Mountains guarantee unpredictable weather. Shifting clouds and light give a constantly changing scene, as in this sequence of shots of the Hindu Kush; the light changed rapidly within just a few minutes.

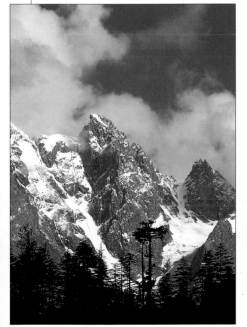

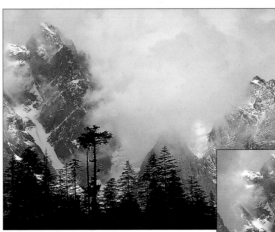

Case study: **changing light**

Perhaps the single most striking quality of mountain light is its clarity. This clarity manifests itself in a number of interesting ways: distances seem less, skies are darker, contrast is higher, and sunlit scenes tend to look sharper. The idea in this case study was to explore the variety of lighting conditions found in one location by working at different times of day, and from a variety of viewpoints. The setting was the plateau of western Tibet in fall, when skies tend to be clear.

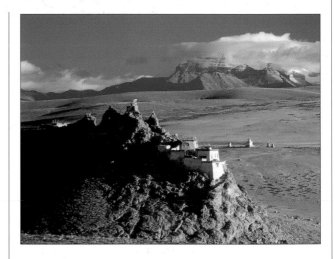

2 Early morning, an hour after sunrise, at 16,400ft (5000m) on the Tibetan plateau. Visibility was very good, diminishing the apparent distance to the mountain, which was 12 miles (20km) away.

3 A wide-angle lens (20mm efl) used vertically took in a considerable height of sky. The natural darkening of the sky and some vignetting from the lens gave a deep, intense blue without a polarizer.

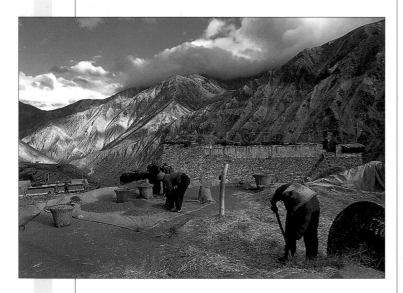

1 Evening light with gathering clouds brought a wide range of colors to the exceptionally clear sky.

6 Silhouettes against sunlit snow are always strong, but the exposure needs to be accurate and geared to the snow, which should be white but not off the end of the scale. A quick check of the histogram is a good idea.

4 This late afternoon shot over Lake Manasarovar was taken with a medium telephoto. The play of light and shadow from the clouds is very well defined.

5 Midmorning sunlight at nearly 19,680ft (6000m) gave very high contrast to the snow-covered face of Mount Kailash. Exposing correctly for this gave a sky that was almost black.

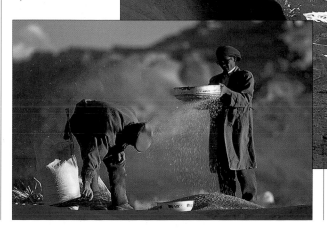

7 Farmers winnowing in the evening light. The clear air gives sunsets that are bright and intense, but rarely richer in color than orange (red sunsets occur in thicker atmospheres).

Tropical light

A high sun for much of the day and very rapid sunrises and sunsets make shooting in the tropics a different experience, with short periods of attractive lighting.

For most of the year in the tropics, the sun is almost directly overhead in the middle of the day, and its effect on the distribution of light and shade is unfamiliar to many photographers. If you live in the middle latitudes—New York, say, the Midwest, or Europe—your idea of a high sun is probably around 60 degrees above the horizon. For a few hours a day in the tropics, however, there is no sense of front, back, or side to the sunlight. Shadows lie directly underneath objects. Roofs and awnings cast deep shadows, but under many subjects, such as people or cars, the shadows are very small. Anything flat, like most landscapes, appears without any shadows at all.

It would be easy to brand this overhead light as unattractive, and by conventional standards it probably is for many subjects. However, it would be too dogmatic to dismiss it as being generally unsuitable. It can play a part in conveying the atmosphere of the tropics. Look for scenes that convey the impression of heat, images with stark contrast, and patterns of light and shade that are distinctive to the tropics—for instance, long, downward-pointing shadows on a bleached wall; a face completely shaded by the brim of a hat, and so on. In other words, look for images that say "tropical" through the quality of lighting as much as through the subject matter.

Portraits and landscapes are the two subjects that suffer most under the harsh lighting of the tropical sun. A face directly under the sun will have prominent, deep shadows under the eyebrows, nose, and chin; moreover, the eyes, which carry so much of the expression in the face, will be fairly well hidden by shadows. The lighting problem for landscapes is almost the opposite: a lack of shadow. There is, as a result, less sense of shape and

Heat and sun
People living in the tropics usually shelter from the sun, and this can be used as a visual symbol. This worker in Manila is heavily masked, despite the heat.

texture to the landscape, and consequently a weaker perspective. To avoid this, you should shoot earlier or later in the day; alternatively, an immediate answer for a portrait is to shoot in open shade, but be careful to set the white balance accordingly.

The sun rises and sets more or less vertically, which at least makes it easy to predict its position for aligning subjects with sunrise and sunset (*see pages 62-63*). However, rising and setting like this, the sun appears to move quickly and dusk and dawn are short. If you are used to the time that is normally available in a temperate climate for preparing a shot or changing position, you may be caught out when you first photograph the tropical version.

▶ **Flat light**
In flat subjects, like this beach landscape off Borneo, there is nothing to cast a shadow under the vertical lighting, and the contrast range is remarkably low.

▼ **Overhead light**
With the sun very high for much of the day, shadows tend to pool under subjects, and high contrast is common, as in this shot of an egret. The typical distribution of light and shade is highlights above, shadows beneath.

Available **Light**

Among the variety of light sources used in photography, the artificial lighting found in houses, offices, city streets, and public spaces is often considered to be the poor relation. Daylight is the natural source of light. Photographic lighting (discussed in the next section of this book) is purpose-built and so designed for camera and lens settings that are close to ideal. What remains, generally known as available, ambient, or existing lighting, can be problematic, but may also be interesting.

Available light used to be at best a challenge, with a great deal of built-in uncertainty. Available light levels are lower than ideal for use with film, so one of the issues was whether to sacrifice detail by opting for a faster and so grainier emulsion, or accept some movement blur by staying with a fine-grained emulsion and using a tripod for steadiness. Another issue was color balance, involving first a choice of daylight or tungsten film, and second a choice of filter (assuming that you had already invested in a set sufficiently comprehensive). This was on top of having a method of judging the color of the lighting: namely a color meter, experience, or guesswork.

Digital photography does away with all of this at a stroke, and available light becomes a pleasure—or at least an arena of lighting situations that is almost as easy on the camera as it is on the eye. This has some very important practical effects, on time and cost. There is almost no need for advance planning and calculation. You can decide in an instant what the color balance is likely to be (note the emphasis on the imprecise "likely"), then choose the appropriate white balance and check the result. If it is not quite right, you can go back to the menu and adjust it. It should take no more than a minute to reach a passable color balance in even the most difficult conditions.

And then there is the issue of cost, which affects the number of different shots that photographers attempt. Available light is often patchy, with the light sources themselves frequently in shot, and this encourages bracketing and different filter combinations just to be safe. Or rather, it used to encourage this, but now the immediate view on the LCD screen shows you what adjustments to make. No longer do you need filters, or backup rolls of tungsten and high-speed film, or a second camera body for them. A single digital camera has it all, and this surely takes the pain out of available-light photography.

Daylight indoors

Photographing interiors by the light through a window is easy enough, provided that you pay careful attention to the window itself, which can give exceptionally good modeling.

The most valuable quality of daylight indoors is its naturalness. Although there are some technical difficulties with light level, contrast, and the uncertainty of the color balance, the quality of light from a window is often both attractive and useful. In fact, the most commonly used form of still-life lighting is based on this effect: boxed-in area lights are designed to imitate the directional but diffuse natural lighting from a window.

The typical source of indoor natural light is a window set conventionally in a wall. Which way it faces and the view outside it control the amount and color of the daylight entering the room. Look carefully at the view out of the window to determine whether or not there is likely to be a major rise or fall in color temperature. The walls of any neighboring buildings may have a much greater effect than the sky.

If there is no direct sunlight (or if this is diffused by net drapes, for instance), then the window is the source of light. This has an important effect

Unexpected effects

When the sun is low enough to shine through a window and across a room, the light will pick out objects—though not for long, as the sun's position moves relatively quickly at these times. Here in a Catholic church, it shone directly onto the ladder used each evening by the bell-ringer.

Frank Lloyd Wright

To avoid window highlights blowing out, choose the camera position carefully. In this room designed by American architect Frank Lloyd Wright, the viewpoint ensures that most of the sky is hidden—farther back would cause too much flare, farther forward would lose the shape of the awning.

on the intensity, as the light, instead of being constant at any distance, falls off rapidly (*see page 13*). This means that, if you are taking a portrait by diffused window light, then how close your subject stands to the window will make a significant difference to the exposure. If you are photographing the room as a complete interior, the level across the picture may be so great that you need some remedy to reduce the contrast.

Light from a window is a distinctive mixture of being highly directional and broad, so the shadow is even, simple, and soft-edged. This combination of qualities makes diffuse window light almost unequaled for giving good modeling, and can be particularly successful for portraits and full-figure shots. This modeling effect is strongest when the window is to one side of the camera's view; the density of the shadow, and thus the contrast, will depend very much on what happens on the other side of the room: whether there are other windows; how big the room is; and whether it is decorated brightly or not. If the shadow side of the picture is dark and you want to preserve some detail, you can add reflectors.

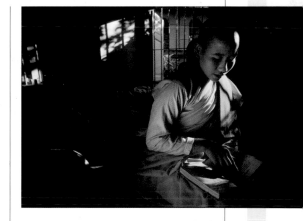

The value of reflection

Bright sunlight falling on a patch of floor in front of this young novice nun illuminates the shadowed area of her face and pink robes—an effect that not only makes the details visible, but is beautiful in its own right.

Bright window techniques

A typical interior is lit during daytime from the side, by one or more windows, and the extremely high contrast between the light indoors and the view outside calls for special techniques if you want to capture both in a single image.

Shots facing away from and toward the window will produce strikingly different effects. With your back to the window, the lighting effect is likely to be very flat, unless beams of sunlight modulate the view. If you shoot into the light, the contrast will naturally be high, but flare from the edges of the window can produce a more atmospheric image. It is important also to realize that the light from one window falls off strongly from one side of the room to the other (*see the Inverse square law on page 13*), and this may call for correction either by using a graduated filter when shooting, or by using a gradient adjustment in image-editing software at a later stage.

▽ Colored lights
This suite in the Lake Palace Hotel, Udaipur, is famous for the effect of its colored windows at sunrise. Keeping the maximum color without underexposing the room involved hidden photographic lights left and right.

If you want to capture what is going on outside the window as well as inside the room, there are special techniques that will help. One is to add lighting to the interior to balance it with the daylight outside (we deal with this later). Another, which needs no other lighting, is to take two exposures on one frame. The first is timed to record the outside scene through the window, and the second adjusted for the interior details. In the first, the interior will be grossly underexposed; in the second, the window will be overexposed. The idea is to match the two images in perfect register as layers in Photoshop, and erase the unwanted parts of the upper layer.

There may be a difficulty when the brightness difference between outside and inside is extreme, in that the exposure for the interior can cause excessive flare around the window edges. To an extent you can correct this in the image-editing program by selecting the flared area and tweaking its brightness, contrast, and saturation, but it may be easier overall to shoot with the window covered. Cover it from the outside, ideally using a black cloth. This is, admittedly, an effort, but it is worth it to achieve a professional result.

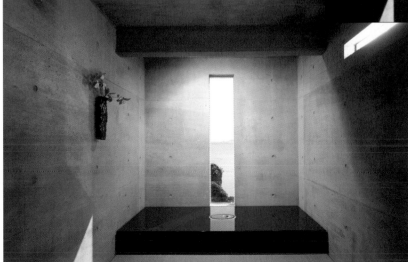

▶ Brightness range

A technically impossible shot without two exposures, this modern Japanese tea-ceremony room features a carefully aligned view through a narrow window. In the first frame (top), exposure was calculated for the interior, in the second (above), for the view. In an image-editing program the brighter image was copied on top of the darker as a second layer. Then a mask was created for both windows, and with this chosen as a selection, the overexposed areas deleted—leaving the outside view showing through. A special difficulty was the flare in the brighter of the two shots; this was included in the mask as a gently brushed-in percentage.

Incandescent light

The orange cast of domestic tungsten lamps, which is much more obvious to the camera than to the eye, needs white-balance adjustment, although not always to the maximum.

Tungsten lamps are the standard, traditional form of lighting for domestic interiors, and this is where you are most likely to find them. Outdoors, and in large interiors used by the public, they have mainly been replaced by fluorescent and vapor lighting. A tungsten lamp is incandescent—that is, it shines by burning—and its brightness depends on the degree to which the filament is heated. As this in turn depends on the wattage, you can get an idea of the brightness, and the color, from the rating of the lamp. The color range, which is between orange and yellow, depends on the color temperature (*see pages 18-19*).

Color temperature is perhaps the first thing to think about when shooting by available light in houses. If you enter a shuttered, tungsten-lit room straight from daylight, you can immediately notice how orange it looks. Usually, however, we see tungsten light at night, and it does not take the eye long to adapt and to see it as almost white. However, photograph a tungsten-lit interior uncorrected—that is to say, with a "sunlight" white-balance setting—and you may be surprised at the orange cast, which will not be what you remembered. The table on page 18 gives the color temperature values for the usual ratings of domestic lamp. These are lower—that is,

▲ **A familiar light source**
Tungsten lamps are one of the oldest forms of artifical lighting, the direct successor to candles, and although largely superseded in public and office spaces, are still the preferred type of domestic lighting.

▶ **Lights in shot**
A typical lighting situation with tungsten, flames, and other incandescent lighting is when the light sources appear in shot, as in this picture of the Amarvilas Hotel in Agra. Experiment with different exposures to get the right visual balance.

Streaked time exposure

A procession of worshipers carrying paper lanterns passed in front of this northern Thai temple, leaving a strange flow of orange light across the foreground in this two-second exposure. The camera was mounted on a tripod.

redder—than the 3200K rating for standard "incandescent" white-balance correction, and so will still appear rather warm even with this setting, although normally this is quite acceptable. As with so many things in photography, the complete answer is not a purely technical one. The ultimate criterion is what looks right, not what measures perfectly. This color temperature, as we will see later in the section on photographic lighting, is normal for photographic tungsten and tungsten-halogen lamps.

In the examples shown right, the subject was a Javanese classical dance, and the lighting was tungsten floodlights with a color temperature of about 2900K. One shot is shown with a "sunlight" white balance, the other with "incandescent." How you judge the results of this and your own shooting will depend on your taste. In this example, my own feeling is that either version is acceptable. The color difference is immediately obvious when compared side by side, but if you cover up the corrected version, the other does not appear to be quite so red. In fact, sometimes the orange cast of uncorrected tungsten light can be attractive, as it gives connotations of warmth and comfort. This may be worth bearing in mind. As an interesting aside, traditionally butchers' shops and meat markets have used tungsten lighting, for the simple reason that it makes the meat look a little redder. By contrast, imagine how unappetizing it would look by green or blue light.

Acceptable warmth

This pair of photos was taken under the same tungsten lighting in Java. The right shot was taken with the white balance set to 5400K sunlight, the top set to 3200K incandescent. What this shows is that the warm tones of under-corrected tungsten are visually acceptable, and the value of correcting the color temperature is a matter of personal taste.

Fluorescent light

One of the most common types of indoor lighting, fluorescent lamps look white but photograph green, and call for white-balance correction.

Fluorescent lamps have a discontinuous spectrum and produce, usually, a greenish color cast. They work by means of an electric discharge passed through vapor sealed in a glass tube, with a fluorescent coating on the inside of the glass. These fluorescers glow at different wavelengths, and have the effect of spreading

Variety of lamps

Fluorescent lamps are available in several different shades of white. These have a visual effect, obviously, but have an even stronger difference in photographs. The most common are "Daylight," "Warm White," and "Cool White," but in practice it is difficult to tell which you are dealing with in a new situation. Make an immediate test at any setting and check the results on the LCD screen.

Mixing sources

The real problems arise if you mix fluorescent with other sources of light, something we deal with on pages 112–113. Adding flash will emphasize the color difference, unless you filter the flash green and use the fluorescent white-balance correction.

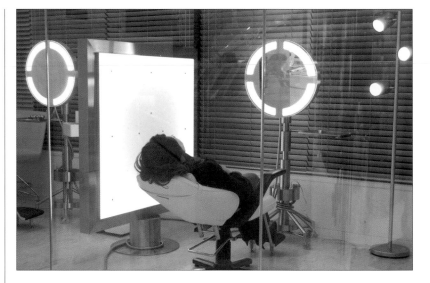

▽ Fluorescent emissions

Covering the full range of the visible spectrum, from violet to red, these bar charts show the different emissions from different types of fluorescent lamp. The visual effect is approximately the total of what you see here.

△ Fine-tuning adjustment

A Tokyo beauty salon lit entirely by fluorescent lamps. The lights visible in shot are sufficiently overexposed to lose their apparent color.

▷ Typical green

This barrel-aging room in a Napa Valley winery is, like many industrial interiors, lit by overhead fluorescent striplights. The difference in color cast is obvious between a frame shot with the camera's white balance set to daylight (left) and a second set to fluorescent (right).

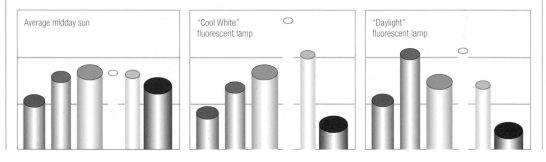

Average midday sun

"Cool White" fluorescent lamp

"Daylight" fluorescent lamp

the spectrum of the lamp's light. Visually this works very well and the eye registers the light as white, if a little cold. However, in photography, this colors the scene unattractively.

If these deficiencies were consistent, it would be a simple matter of using one standard white-balance correction. However, as the bar charts on page 108 show, fluorescent lamps vary in the visual effect that the manufacturer tries to produce. Some are only slightly green when photographed; others are very green. All digital cameras have at least one white-balance correction setting, but some feature a choice, with, for instance, separate settings for "Daylight," "Warm White," and "Cool White" lamps. It is difficult to tell just by looking how much of a green cast will appear. It is usually best to test it by shooting with the basic white-balance setting and then adjusting from there.

A large part of the problem, esthetically, is that an overall bias toward green is considered unattractive by most people, except in special and occasional circumstances. As you can see from the section on tungsten lighting (*pages 106–107*), a shift to orange is generally tolerated. The same is not true of green. Whereas orange is a color of illumination that is within our visual experience (e.g. firelight, rich sunsets) and has, on the whole, pleasant associations of warmth, green is not a natural color of light. Although this is a fairly good reason for wanting to make corrections, you should, as a first step, think about whether you can make some use of the green cast, or indeed whether the color will make any important detrimental difference to the image.

Acceptable color cast

One reason why it may not be important to make a color correction is sheer familiarity. Fluorescent lighting is used so much in large interiors, such as supermarkets and offices, and so many uncorrected and under-corrected photographs are published, that we are all accustomed to seeing the greenish color cast. It can usefully add a cold, industrial atmosphere to a scene, or add interest to an otherwise flat shot.

◣ When green is acceptable
Vertical strip-lights cast the usual greenish light in this shot of Bangkok's Emerald Buddha. Filtration would have made the green statue appear duller.

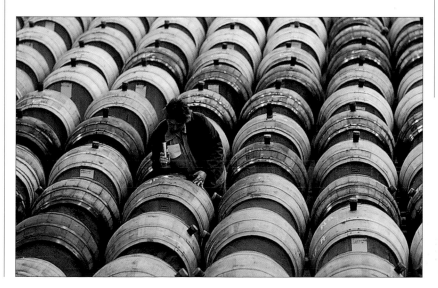

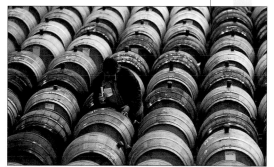

Vapor discharge light

Digital capture comes to the rescue in what have traditionally been some of the nastiest lighting situations in photography—the greens, blues, and yellows from vapor lamps that often look deceptively white.

Vapor discharge lighting is definitely on the increase, particularly in public spaces and department stores, and is gradually taking over from fluorescent and tungsten lighting. Being more powerful than either of these two, vapor lamps are good for lighting large spaces brightly, both outside and inside. What they are not good for, unfortunately, is photography. The problem is that, for the most part, they look white to the eye—which is why they are popular—but in photographs they usually cast a strongly colored light over the scene. Worse still, they are not consistent or predictable.

The three principal types of lamp are sodium, which looks yellow in photographs; mercury, which looks like a cold white and photographs between green and blue-green; and multi-vapor, which also looks cold white but may, if you're lucky, appear reasonably well balanced in a photograph. Sodium lamps are typically used for street-lighting and for floodlighting buildings; multi-vapor lamps are used in sports stadiums where television cameras need good color balance; and mercury lamps are used in lots of different situations. Sodium is easy to spot—it looks yellow and, when just switched on, glows orange for a few minutes. The other two easily fool the eye, although when mercury lamps are switched on, they glow greenish before they reach full strength (note that if you switch them off to check how the scene looks without them, it may take several minutes to restart them).

The reason for the problem is that the emissions of vapor discharge lamps peak strongly in very narrow bands of the spectrum, and are completely lacking in many wavelengths. Unlike fluorescent tubes, they don't have the benefit of a coating of fluorescers to spread the output over other parts of the spectrum. With film this made for a truly difficult situation, but digital cameras score in two ways: the normal response of the sensor to vapor lamps is less extreme than with color film; and the white-balance menu lets you reach a neutral color balance—or something close to it at least.

◭ Colour contrast

The visual mixture of green vapor lighting in this glass lobby and cool dusk daylight produces a delicate effect that it would be a pity to lose, even though the green could be shifted to neutral in image editing.

◮ Sodium yellow

The yellow cast from sodium vapor lamps is intensified by reflections in these stainless-steel wine vats. Neutralizing the cast is possible in-camera, but here the yellow added to the severe, industrial scene.

A variety of color

In this shot of an East Malaysian oil refinery, the blue-green lights are mercury vapor, and the yellowish are sodium. However, from this distance it is not worth using color correction, as the lights are only a small element in the composition.

Intense green

The vapor lighting on this old church is basically uncorrectable in-camera because of its extremely restricted spectrum. One solution is during image editing to alter the hue to something more visually acceptable, while reducing saturation. The difficulty is that the range of hues is so narrow that a normally colorful result is impossible.

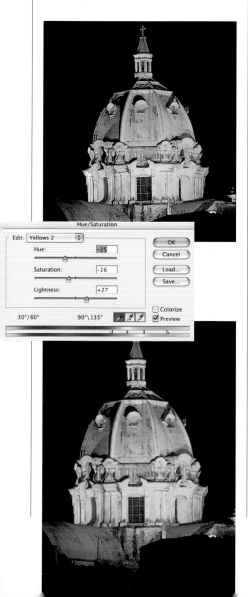

Mixed lighting

When interiors combine different kinds of lighting, you can expect a clash of colors, but for shooting you will have to choose one white-balance setting that makes the best of the situation.

One trend in lighting interiors, particularly large spaces, is to mix light sources from incandescent, fluorescent, and vapor discharge lights. Again, the issue to address in photography is the gap between what the eye sees and what the sensor records. Mixed lighting works because our eyes accommodate to color changes so easily, but the camera's response will nearly always show up the differences within the same scene.

Depending on how the lamps are situated, they may combine to give a blend of color, or they may cast separate pools of differently colored light.

Once again, digital cameras come to the rescue in a way that was impossible with film photography. Not only is the color response of the sensor less extreme than that of film, but you have the advantage of an instant feedback in the LCD display. Before anything else, I shoot a test frame with the widest angle of lens focal length I have, simply to examine the relative difference in color across the scene. The white-balance setting for this test is not critical, but for an accurate measurement I normally set it to "sunlight." On the basis of this I can decide whether to switch off certain lights, and then find the least offensive white-balance setting.

However, before heading toward correction, you might want to pause and consider whether or not the mix of lighting colors is a bad idea after all.

The positive side of mixed lighting is that the color combinations can be intrinsically attractive and contribute to the image. Then again, the unattractive associations of green light may be exactly what you need if you intend to convey a particular kind of atmosphere. Institutional settings, such as the emergency reception area of a hospital, a seedy bus terminal or subway, are likely to look more effective if the fluorescent lighting is left uncorrected.

▽ The warmth of candles
Traditonal English afternoon tea is still served in an old hotel in Darjeeling, India, with candles lit. Shooting through to the room beyond gives the shot context, but also includes the daylight through the far window. Although inacandescent lighting dominates most of the image, the white balance was set for little correction, partly to keep the daylight looking normal, partly to retain the expected warmth of the candlelight.

◭ A complex mix

This Tokyo department store has a bewildering mixture of lights, from tungsten to fluorescent to vapor discharge. The net effect, however, with the camer's white balance set to Auto, is a surprisingly normal blend, as one cast cancels out the other.

▷ Complentary colors

A straight mix of daylight and tungsten might seem to be a color-balancing challenge that could only be solved selectively during image editing. However, the basic attraction of the shot is precisely the harmonious contrast between orange and blue, and it was important to set the white balance midway between the two sources to capture this effect.

Post-production techniques

Even the most intractable problems of mixed lighting, with conflicting colors from different lamps, can be solved after shooting by using Photoshop to bring unwanted colors into line.

One of the most valuable techniques for dealing with mixed lighting after the fact is to use image-editing tools to extract offending colors. There are a number of ways of doing this; none of them is particularly difficult. Remember that the core of the problem is that the lighting in various parts of the scene is differently colored, which makes overall changes out of the question, just as when shooting. A typical situation might be daylight plus mercury vapor when the shot was given a white-balance setting of "sunlight." In this case, the aim would be to select the green from the mercury vapor alone, and then neutralize it.

Step one is to select the color that you want to remove. Usually, my method of choice in Photoshop would be Hue/Saturation under the Adjustments section of the Image menu, although Replace Color in the same drop-down menu performs the same function. In either case, the principle is to select the range of color that you want in HSB mode. A possible drawback is that this will select all greens within the range across the image, and there may be some that were not due to the lighting—in other words, ones that you want to keep. The answer here is to protect them by painting over them in a masking layer, as shown in the sequence below.

▲ Select a restricted area

When the offending color appears in other parts of the image for other reasons, protect these areas from change by masking. In this example, the lighting was fluorescent, but the tubular light fittings were also intentionally bright green.

▶ They were protected by tracing round them with a pen tool to create a path, and a selection made from this.

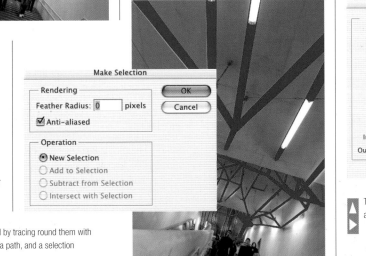

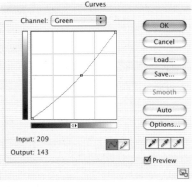

▲
▶ This selection was then inverted, and a simple color adjustment applied in Curves.

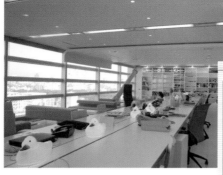

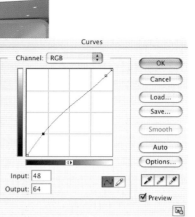

Go for green

In this shot, the green cast from fluorescent striplights was unavoidably added to daylight (for which the shot was balanced) and some tungsten lighting.

Balance the tones

The first step was to balance the tones in this inevitably high-contrast shot, using Curves to lighten the shadows.

Careful correction

Then, using the Hue/Saturation controls, greens were chosen, and by clicking the sampler tool on the ceiling, the exact range of green was fine-tuned. This narrowed the range over which the correction would be made. I then experimented with the three slider controls Hue, Saturation, and Lightness to shift and reduce the color. Desaturating is a gentler adjustment than shifting the Hue. I left the Lightness alone.

City lights

Downtown street lighting and display lighting continues to get brighter and more colorful around the world, and is perfect material for digital shooting.

The light sources available outside at night are the same types as those that we have just looked at, but in different proportions. Vapor lamps are used much more extensively outdoors than indoors, because of their higher output; this is particularly true of street lighting and floodlighting. Tungsten as street lighting is increasingly less common, but can be seen in store and other windows and as car lights. Overall, entertainment and shopping districts in cities are getting brighter and more interesting.

Although the light sources are the same as those used to illuminate interiors, their effect is very different. The scale of the usual type of outdoor shot is greater, and the surroundings do not give the same degree of

▽ Keeping it bright
A Shanghai street packed with seafood restaurants has a lighting level to match the buzz of night-time business. Shots like these always repay bracketed exposures—the brighter frames are usually most successful.

Light reflections

To get the most out of the fairly low lighting on a canal in London, I shot with a long telephoto at an acute angle to the moored canal boats (to catch reflections in their side panels) and from very low, for maximum reflections in the water. Without these two kinds of reflection, the shot would have been hardly readable—as it is, the effect is atmospheric and slightly mysterious.

reflection as do interior walls and ceilings. As a result, there is much more pooling of light: in a typical scene there are many lights, and they are localized. Only very rarely are there enough lights in a concentrated area to give the impression of overall illumination. This happens, for instance, in the busiest part of a downtown night-club district; at some open-air night-markets; and, as you might expect, in sports stadiums. A general solution to this is to shoot at dusk, when there is just a little residual daylight.

In most night-time city views, however, there is either one well-lit area, such as a floodlit building, or a pattern of small lights. In many ways, this type of light causes fewer difficulties than an interior, and there are fewer occasions when you might need to decide on the principal light source and correct the color. The impression of a color cast occurs when most of the picture area is affected; when there are other lights in the image, color balance becomes a much less important consideration.

The localization of the light sources makes measurement difficult. Use it as a guide rather than as a completely accurate recommendation, and bracket exposures around the figures given. For many night-time scenes, the accuracy of the exposure is not, in fact, very critical. Overexposure often does little harm, as it opens up the shadow areas in a scene. The best answer is to experiment, which is of course what digital cameras allow.

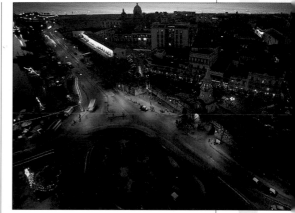

City at dusk

Twilight just after sunset is here an important element in an elevated view of a Caribbean city. Its muted but general illumination helps to give definition to buildings and streets, in what would otherwise be a picture composed solely of dots and streaks of light.

Lighting displays

Outdoor lights as subjects rather than illumination need more careful exposure to preserve colors and shapes, while fireworks are a special case that calls for anticipation.

Although these are fluorescent lights, the colors of the displays overwhelm the greenish color cast typical of fluorescent lighting, and the white balance rarely needs to be accurate. Most displays are high up–well above street level–and the easiest technique is usually to stand back, across the street or farther, and use a telephoto lens. For one exposure, use the fluorescent white-balance setting, just to be able to see what difference it makes. Apart from this, take a series of different exposures, starting with the meter reading and increasing the exposure from that. If you are using a tripod, there will be no need to increase the sensitivity, and in any case you will need to keep the shutter speed at 1/30 second or slower to compensate for the tendency of fluorescent lamps to pulsate.

Which exposure looks best is usually a matter of taste, and the range of what is acceptable is quite wide. When comparing the results later, you should notice that short exposures give more intense colors, reproduce the tubes as thin lines, and show nothing or very little of the surroundings. Longer exposures give a thicker appearance to the display, which appears paler in color also. If you use a tripod and so have perfectly matched frames, it might be interesting to take two different exposures and combine them in a single image in Photoshop, keeping the color saturation of the darker frame.

Fireworks displays, like lightning, make their own exposure. Light intensity apart, there is little point in trying to use a fast shutter speed: the effect of a bursting fireworks display is created by the streaking of the lights, even to the eye. A short exposure simply shows less of the display. Conversely, provided that the sky is really black, leaving the shutter open will not cause overexposure, but instead add more displays to the image. Two things to be careful of are the clouds of smoke from the fireworks that sometimes drift across the view, and the lights of buildings if you include the setting in the shot. Both of these set limits to the overexposure.

For the best effect of the bursts, exposure times are usually between half a second and four seconds, but you can judge this for yourself by watching the initial displays and timing them from the moment the rockets reach their bursting height. There is no need to switch to a higher sensitivity: f4–f5.6 is a

Display cycles
Some neon displays cycle through changes as striplights switch on and off in sequence. Try different moments in the cycle, and also vary the exposure. Neither of the exposures above is right or wrong—simply a different effect. Color is stronger with shorter exposures, but a luminous glow needs longer.

reasonable aperture with ISO 100–200. In any case, the exposure is not critical: try making a variety of exposures to determine this for yourself.

For a view of a firework display that includes the setting, as in the photograph below, lock the camera firmly on the tripod, and make sure that the framing and focal length are right for the height of the displays. Check this and the location of the fireworks by watching a few through the viewfinder before shooting. For a close view of a single burst, try using a medium telephoto lens with the tripod head partially loosened (enough so that you can move the camera, but still sufficiently tight to hold it when you stop). Pan upward to follow the rocket as it ascends and, as soon as it bursts, stop and open the shutter.

 Colored neon
The green-cast issues of shooting by fluorescent lighting are irrelevant with strongly colored displays such as this. The greenish cast remains, and you would still probably want to set the white balance accordingly, but this is largely overwhelmed by the coloring.

▶ **Fireworks**
To take a wide-angle photograph of fireworks in a setting, use the start of the display to judge the height and position of the bursts, and frame the shot accordingly. With the camera locked on a tripod, vary the exposure times to include single and multiple bursts. This shot was taken in New York at the centenary celebrations of the Statue of Liberty. The lens's focal length was 35mm equivalent (slightly wider than standard), and the aperture f2.8 with basic ISO 100 sensitivity.

Photographic **Lighting**

What sets photographic lighting apart from other light sources is that it is designed specifically to work with cameras and certain popular kinds of subject. On-camera flash is a standard does-everything light, but has serious limitations when it comes to creating a carefully arranged, imaginative setup. In professional photography, particularly in studios, lighting is a specialized, important, and costly concern. This has always been the case, but as pro-lighting manufacturers improve their equipment, the range increases and can cope with more and more specific lighting situations.

If you were planning to cover the full range of lit studio and location photography, you would eventually find a use for all the sources of photographic lighting covered here—and their even greater number of attachments. However, for cost, if nothing else, most photographers commit themselves to one type of lighting, at least to begin with.

While most of this applies to digital photography as much as to traditional film photography, digital capture is creating some major changes, albeit quietly and even a little subversively. Much of the effort that has gone into pro-lighting in the past has been to cope with the limitations of film. This applied especially to high-powered studio flash, where the systems developed in the 1960s and 1970s were designed for exact color fidelity and motion-stopping output. Digital, however, is much more flexible than film in its response to color, as well as being, in most cameras, more sensitive (the standard high-quality ISO setting is higher than the traditional ISO 50 of fine-grained emulsions). A standard digital camera simply does not need the precision and power of expensive studio lighting. This may be heresy to the purists, but is good news to photographers with smaller budgets. You can use almost any source of illumination, and the digital sensor, with the help of a good white-balance menu, will generally cope with it. For example, if you have a light box for viewing transparencies and are wondering whether to mothball it as you shift to digital photography, try using it as an area light, or for backgrounds. Never mind about color balance—the camera will take care of that.

What I want to stress throughout this section is the importance of controlling the quality of lighting. This may seem obvious, but if you are used only to portable flash, the sheer quantity of materials, time, and effort that goes into full lighting control may be a surprise. In still-life shooting, studio portraits, room sets, and other controlled situations, convenience and simplicity are low priorities. Precise lighting takes time to plan and construct. The top priority is creating as full as possible a range of directions, diffusion, concentration, and all the other qualities of lighting. This takes a lot of effort, and will introduce you to a special class of lighting problem. For instance, diffusing a lamp in a way that suits one object in a group may cause an unwanted spill of light onto another. The main light and background light may (and often do) conflict, and separating the effect of each on the other may call for some ingenuity in managing and placing the equipment.

On-camera flash

Whether built into the camera body or attached via a hot-shoe connection, basic flash units were designed as a convenience for getting the shot in the absence of any other useful light.

In the range of photographic lighting, on-camera flash is principally a convenience, and it is important to appreciate its limitations. Most on-camera flash units are built-in (some pop up on demand), but some are detachable and fit on the camera's accessory shoe. All these units are designed for compactness and ease of use; with these as priorities, quality and variety of lighting take second place. While this kind of flash has its uses on location, it does not have quite as many advantages as its manufacturers would like you to believe. Nevertheless, the sophisticated metering and exposure control in a digital camera makes it possible to mix flash with existing lighting for some dynamic effects.

Guide number

The guide number is a practical measurement of output, and varies with the ISO sensitivity. It is the product of the aperture (in f-stops) and flash-to-subject distance, in feet, meters, or both. A typical manufacturer rating, for example, might be "Guide Number 17/56 at ISO 200," meaning meters/feet. Divide the guide number by the aperture you are using to find the maximum distance at which you can use it. In this example, if you were using an aperture of f4, it would be 4m (14 feet). When using a unit off-camera, remember that the shadows will be larger and the contrast very high unless you use a reflector or a second flash unit opposite. Off-camera flash is easiest to use with the assistance of someone else to hold the flash unit.

Intense color

The great value of portable flash is that it makes it possible to take at least some kind of photograph in situations where there is insufficient light. Direct, on-camera flash pictures usually work best when the subject has strong tones or colors, as here.

Flash units work by means of a capacitor charged by battery. When triggered, the capacitor releases its full charge instantaneously through the flash tube, ionizing the gas inside. Intensity of the light output depends on the size of the capacitor and on the square of the voltage at which the unit operates, and is normally quoted as a guide number.

The limitations of full flash illumination are those of frontal lighting. In other words, the light is almost shadowless and it falls off in proportion to the distance from the camera. A typical purely flash-lit photograph tends to feature flat illumination on the main subject and a dark background. The result is clear, sharp, and with good color separation, but is generally lacking in ambience. Typical good uses of full-on flash are close-ups of colorful subjects, as these can benefit from the crisp precision and strong colors afforded by flash illumination.

Problem checklist

☐ Exposure is good only for one distance, because the light falloff is along the line of view. Thus backgrounds are typically dark, and off-center foreground obstructions typically overexposed.
☐ There are often intense reflections in shiny surfaces facing the camera (spectacles, windows, etc.). Lack of a modeling lamp prevents preview.
☐ Red reflections from the retina of the subject are likely, particularly with a longer focal length lens (this makes light more axial). The solution supplied by some cameras is a pre-flash to make the person's iris contract, but this adds a delay.
☐ Flat, shadowless light that gives a poor sense of volume.

▼ Automatic fill
Letting the camera decide on the balance between ambient light and flash gives an efficient, if slightly unnatural, effect—as in this shot of a man steering his boat along a canal.

▲ Crisp, sharp, and clean
While the small head of a portable flash unit prevents subtlety in lighting, it has the advantage of bringing out texture and color very vividly, particularly when, as in this picture of a fighting cock, the flash is used from a slight distance off-camera, using a sync cable. The background as usual disappears to black, which in this case helps the bird's head stand out strongly.

Making more of flash

By adding to the ambient light rather than totally replacing it, on-camera flash can achieve interesting effects, and even subtlety. Experimentation is easier than ever with digital cameras.

While on-camera flash works well enough as a no-frills light that at least enables you to capture a recognizable image, it totally changes the view of any scene, usually dropping the background right out of sight. There are ways of working around this, however, including diffusing the light and using it in combination with a longer exposure. A slight amount of diffusion is possible by fitting a translucent attachment to the flash head, but there are physical limits to this as the diffuser attachment has to sit above the lens. More usual in interiors with low, domestic-style ceilings is to use bounce flash, swiveling the head upward so that the light spreads by reflection (only with white or pale ceilings).

Adding to the ambient light, however, is one of the best uses of on-camera flash, and there are two variations of it. One is shadow fill. This is especially useful when you are shooting toward the light and detail in objects facing the camera tends to be lost in shadow. All digital cameras have a setting for this, in which a smaller dose of flash is added to the longer exposure so as to give a balanced combination. The second variation is streaking with rear-curtain synchronization. In this, the exposure and flash output are similarly balanced, but the flash is timed at the end of the exposure. If there is movement, either in the subject or because you move the camera, there will be trails of light terminating in a sharply frozen image.

Manual balance

When there is time to consider a shot and make adjustments, it's usually better to select the amount of fill flash yourself in Manual mode rather than accept the standard Auto calculation. In this scene of fire prayers in a Japanese Buddhist monastery, the soaring flames were the key subject, and flash was needed only to make the monk visible. Auto would have drowned the scene in flash.

Bounce flash

This technique works only with flash units that have swiveling heads, and relies on having a white or pale-colored surface close to the camera. One of the most readily available is the ceiling of a room, and most such units are designed to tilt upward and make use of this. The effect is to diffuse the light and to alter its direction. The light intensity is, expectedly, very much reduced.

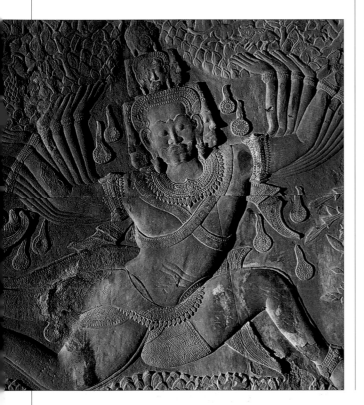

◢ Off-camera for texture

To light this sandstone bas-relief at Angkor Wat effectively, the angle had to be acute—just grazing the surface so as to throw the delicate carving into relief. A portable flash unit was connected to the camera (an SLR) by a 6-foot (2-m) sync cable.

◢ Judging the effect

A sequence of three frames of nuns in a convent, with varying degrees of fill flash—from none (top) to full (bottom). In a situation like this, the chosen balance is entirely up to personal taste: the trade-off is between the natural effect of existing light and the sharp, bright colors of flash.

Studio flash

Mains-powered flash units offer the ultimate lighting control: a full range of light fittings and no problems with moving subjects.

The real limitation of on-camera flash is that its full-frontal direction and harsh quality are rarely flattering–probably the last thing you would choose if you had control. The limitations of tungsten lighting are that it does not combine with daylight easily and that the great heat output limits the fittings you can attach. For the extra effort of planning and setting up lights, you can achieve a much wider range of effects with powerful,

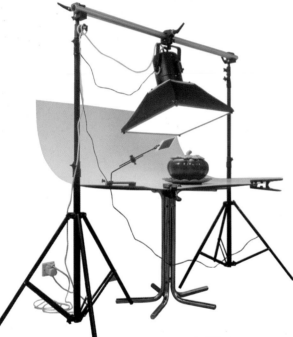

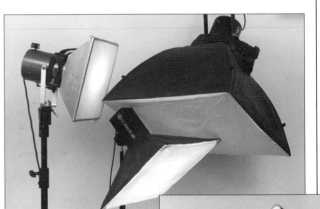

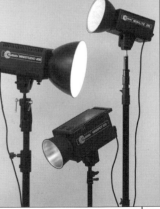

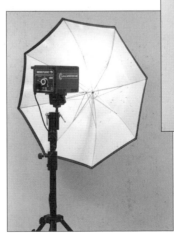

◭ Basic still-life setup

Lighting setups are endless in their possibilities, and much of the pleasure of studio photography comes from experimentation and devising your own, elegant solutions. This is a simple starter for objects of handheld size: one light fitted with a window-like bank suspended overhead, and a curved sheet of white flexible material (such as Formica) to give a horizonless background shading from bright to dark.

▶ Light fittings

Because the only heat generated is from the low-wattage modeling lamp, flash heads can take a variety of fittings. These banks (above right) enclose the heads and give a diffuse but directional effect, in addition to standard bowl reflectors (far right) and umbrellas (right). Umbrellas are particularly useful for portraits.

separately triggered flash heads. There are two kinds: high-output portable flash powered by rechargeable batteries; and mains-powered flash, which is normally used in studios. Both can be used with a variety of fittings, and it is these—the diffusers, reflectors, and spots—that control the quality of the light.

Lighting in a controlled environment is the essence of studio shooting, and digital cameras take this to another level of ease and convenience. Many models, and particularly prosumer ones, let the camera be operated directly from a computer. Once the camera is locked on the tripod and the lights are in position, you can simply sit down with a laptop and shoot from the comfort of your keyboard and mouse.

Sync workarounds

By no means all digital cameras include a co-axial flash sync terminal—in fact, fewer do now than in the days of film. Fortunately there are workarounds, although you should check whether these will work with your camera. The most convenient is to use the camera's built-in flash to operate a slave trigger. The better studio flash units have a slave built in, as here on an Elinchrom, to obviate the need for messy cables. If your camera allows it, set the built-in flash to its minimum setting. If not, vary the shutter speed, turn the room lights off, open the shutter, and use open flash, triggering the unit by hand or with a small handheld flash trigger.

Flash meter

A flash meter is essential equipment with these large units, and the most consistent measurements in a studio setup are from incident light readings, made with a milky dome over the sensor, pointed at the camera. This measures the light, not the subject. For close-ups, a flexible miniature attachment is useful.

Shooting from the computer

Many digital cameras provide remote capture through their software and a connection to the computer (usually USB or, better and faster, Firewire). The advantage is in the larger display, which offers better analysis of the image, and the histogram is the key tool; all camera functions are usually controllable.

Studio flash equipment

Being able to draw continuous power at a significant level makes it possible to deliver light that can be diffused, reflected, or redirected in all kinds of ways, and still reach the subject at a level that offers good depth of field.

A mains flash unit works in the following way. As the power supply is in the form of an alternating current in a relatively low voltage, the first part of the circuitry is a transformer and associated rectifier (or more than one in the case of larger units). The transformer steps up the voltage and the rectifier converts the alternating current to a direct current (in other words, it converts AC to DC). This uni-directional high-voltage source then supplies the capacitor that stores the charge. On command, the high-voltage output in the capacitor is discharged through the flash tube.

Given the light output possible from just a single flash tube—and the fact that it is practically instantaneous—it is not surprising that mains-powered flash is the lighting equipment of choice in studios. Output is measured in watt-seconds, or joules, and typical units are between 200 and 1000 joules. To make use of the extremely high output of the mains flash capacitors, the flash tubes are much larger than in on-camera units. Instead of a short straight tube, the most common design for medium-power units is circular. High-output units may use spiral tubes. One result of the need for high output and larger tube size is that the peak flash duration is longer than that of an on-camera flash—sometimes as slow as a few hundredths of a second.

Lampheads
These heads require power from a separate generator unit. This means buying into a particular Flash system, but there are advantages in terms of long-term reliability and fine control.

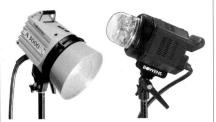

Elinchrom A300N Bowens Esprit head

Monoblocs
Monobloc flash units contain the power supply and controls within the body of the flash itself. This makes them particularly useful when you need flexible, easily portable lighting equipment.

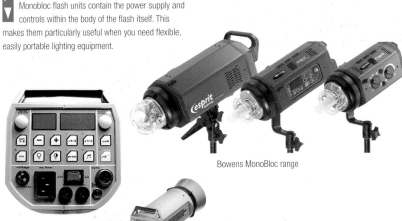

Bowens MonoBloc range

Monobloc controls

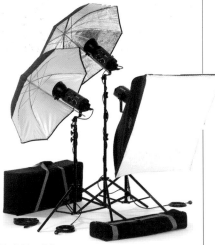

Esprit 3 head kit

Food on location #1

When choosing studio flash units, consider the value of being able to take them on location. If this is likely, they need to be compact and relatively light, as in the case of this monobloc unit fitted with a collapsible softbox. Being able to suspend a main light overhead is useful, but needs extra supports—here a goalpost arrangement of aluminum stands and pole.

Food on location #2

The great value of portable flash is that it makes it possible to take at least some kind of photograph in situations where there is insufficient light. Direct, on-camera flash pictures usually work best when the subject has strong tones or colors, as here.

Power packs

With a seperate power pack and lamphead system, it's possible to channel more power into a single head, or control the spread across several.

Balcon power pack

Elinchrom Ranger power pack

As with other photographic equipment, such as cameras, there are many competing systems, and these are often not compatible. This is particularly the case with mains flash, in which the power units, connectors, and flash-heads cannot normally be interchanged. Before buying anything, make all the comparisons you can, and anticipate your future needs. You might, for instance, eventually need several identical lamps, or a set of specialized lights—one for still-life main illumination, and others for backgrounds, and so on. Also, if you expect to shoot on location as well as at home or in the studio, the weight and transportability of the equipment will be important.

Incandescent

Photographic tungsten lamps and the newer high-performance flicker-free fluorescent lamps have the advantage over flash that you can work by eye, although they are not as effective at stopping movement.

▲ Fill light for rooms

Almost all room interiors shot toward a window need some kind of fill lighting, simply to bring the contrast level into line. Windows are often an important part of the view, as in this shot of a Los Angeles 1930s house, and for shadowless fill, lights aimed behind the camera onto walls and ceiling are usually the most efficient.

Tungsten lighting is incandescent, as we saw on pages 106–107, created by burning a tungsten filament at a controlled rate in a sealed transparent envelope (glass in the case of traditional lamps; a quartzlike material in the case of more efficient tungsten-halogen lamps). When designed specifically for photography, the light output is high and the color temperature is controlled, at 3200K (312 mireds), in nearly every design. Some lamps are available with a blue coating to the glass, giving a color temperature that approximates that of daylight. These are intended more for use in mixed lighting conditions, such as combined with daylight, than for straightforward studio use.

The more efficient version of tungsten lighting is the tungsten-halogen lamp. This uses the same coiled tungsten filament, but it burns at a much higher temperature in halogen gas. As a result, these lamps maintain virtually the same light output and color temperature throughout their life; they also last longer than traditional lamps and are smaller for their equivalent wattage. Available wattages range from 200 to 10,000, although the most powerful are intended for cinematography; the highest normal wattage for still photographic lights is 2000. The light output is the same as that from a new tungsten lamp of traditional design of the same wattage.

A newer development, particularly relevant to digital photography, in which the camera's white-balance settings can take care of color differences, is high-performance fluorescent. The lamps used are flicker-free, almost as bright as tungsten, color-balanced for 5400K or 3200K, as well as being cooler and less expensive to run (though more expensive to buy in the first place).

Tungsten vs flash

Tungsten: pros
☐ Photographs the way it looks
☐ Good for large, static subjects—just increase the exposure time
☐ Mechanically simple, little to go wrong
☐ Easy to use
☐ Can use to show streaked movement
☐ Some units very small and portable

Tungsten: cons
☐ Not bright enough to freeze fast movement
☐ Hot, so can't accept some diffusing fittings, and dangerous for some subjects
☐ Needs blue filters to mix with daylight

High-performance fluorescent: pros
☐ Photographs the way it looks
☐ Good for large, static subjects—just increase the exposure time
☐ Mechanically simple, little to go wrong
☐ Easy to use
☐ Can use to show streaked movement
☐ Inexpensive running costs
☐ Cool—none of the heat problems of tungsten

High-performance fluorescent: cons
☐ Not bright enough to freeze fast movement
☐ Bulky
☐ High unit cost

Flash: pros
☐ Stops any fast action
☐ Cool, quick to use
☐ Daylight-balanced, mixes easily

Flash: cons
☐ No preview with small units, others need modeling lamps used in relative darkness
☐ Fixed upper limit to exposure, beyond which needs multiple flash
☐ Technically complex

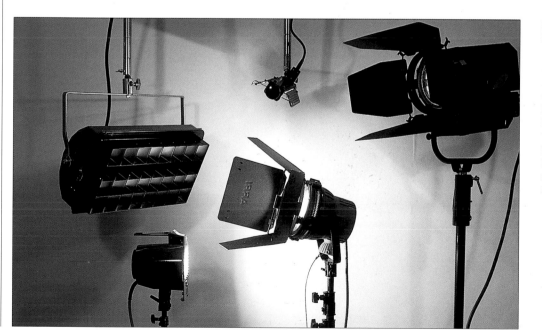

◄ **Types of incandescent light**
Clockwise from top left: Ballancroft 2500-watt northlight fitted with honeycomb or "egg-crate"; Lee-Lowell 800-watt Totalite with barn doors; Rank-Strand 1000-watt Polaris manual spotlight; 800-watt Arrilite; Hedler 2000-watt videolux.

Handling incandescent lamps

The great value of these professional lights is that you get what you see, but the high heat output makes it important to treat them carefully and take the necessary precautions.

The design of tungsten-halogen lamps varies to suit the different makes of lighting unit, but the two main types are both two-pin: single-ended, which is intended to be used upright; and double-ended, which is intended to be used horizontally. It is important, both for safety and for the life of the lamps, to use them only in these recommended positions. Always make sure that the lamps are securely mounted on their stands, and that there is no risk of the stand toppling over (it is a sensible precaution to tape cables to the floor and to secure the stands).

There are other important precautions. You should never touch the quartzlike envelope with bare fingers, as the greasy deposit will cause blackening and shorten the lamp's life. Instead, use paper, cloth, or a glove. If you do accidentally touch the surface, wipe the finger-marks immediately with spirit. If you travel with tungsten lights and carry two sets of lamps for

Types of lamp

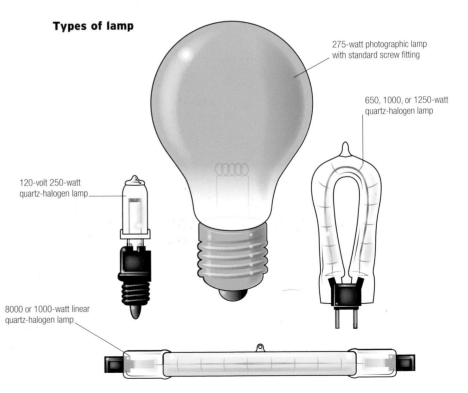

120-volt 250-watt quartz-halogen lamp

275-watt photographic lamp with standard screw fitting

650, 1000, or 1250-watt quartz-halogen lamp

8000 or 1000-watt linear quartz-halogen lamp

different voltages (110/120 and 220/240), be careful to identify the ones fitted before switching on: using a lower-voltage lamp on a higher-voltage circuit will immediately burn it out and may cause damage if it explodes. Not all lamps carry the voltage information on them, so make sure that they are in clearly marked containers if you store them away from the fitting.

These lamps have high operating temperatures and can set fire to flammable materials, such as wood, paper, and fabrics. Keep a careful eye on the position of the light, and keep it at a distance from anything that might be damaged (in particular, the light's own cable: certain parts of the housing can melt it through to the core, which would be extremely dangerous). If in doubt about damage to something, keep touching it to see if the heat builds up. Never enclose a tungsten-halogen lamp in order to modify the light; it needs good ventilation, because of the high operating temperature. Many light housings have folding doors that can be closed to protect the lamp when not in use (open, some act as reflectors; others as barn doors, *see page 134*); never operate the light with these doors closed or even partly closed.

Cable safety
Next, tape the cable to the floor between stand and socket, or if that is impractical, as over a carpet, weight it down and cover it

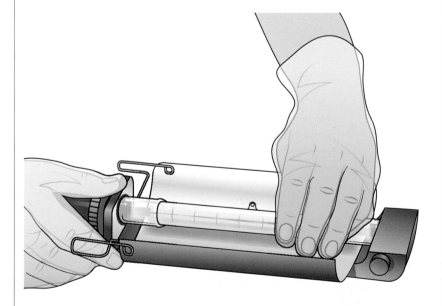

Handling lamps
The envelopes of high-temperature halogen lamps are very susceptible to oil and grease, even the normal amount from skin. They absorb this, shortening their life. Use gloves or a cloth when changing and handling.

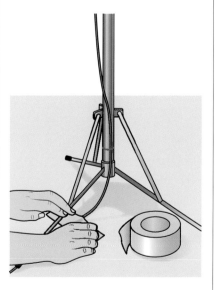

Cable safety
A cable trailing from the top of a stand to a power outlet is easy to trip over, and can pull both the stand and the light down. To avoid this, first secure the cable to the base of the stand.

Incandescent fine tuning

As with studio flash, incandescent lighting can be modified with various attachments, although these must always be heat-proof and adequately ventilated.

Every type of incandescent light housing incorporates some kind of reflector behind the lamp. This is partly to make use of all the light radiated (and so increase the light falling on the subject), and partly to control the beam. The deeper and more concave the reflector, the more concentrated the beam. As it is more difficult to spread a beam that is already tight when it leaves the housing than it is to concentrate a broad beam, most general-purpose housing has reflectors that give a spread of between about 45 and 90 degrees. Light that gives tighter concentration is intended for more specialized use.

Many housings allow some change to the beam pattern by moving the lamp in and out of the reflector, or by moving reflector doors. Barn doors fitted to some housings have a slightly different effect: they cut the edges of the beam rather than concentrate it. The beam patterns from most housings show a falloff from the center outward; even with a well-designed reflector, there is still an intense concentration of light in the lamp's filament. One method of reducing this falloff in the design of the housing is to cover the lamp from direct view with a bar or a spiller cap. If the reflector dish is large as well, the result is a degree of diffusion. Even softer, but less intense light is possible if the inside of the dish is finished in white rather than bright metal.

Used alone in the studio, tungsten lamps simply need 3200K "incandescent" white balance. However, tungsten lighting is frequently used on location, in interiors, and this is often in combination with existing lighting, like daylight and fluorescent light. As a result, lighting filters are typically used for converting the color temperature or for correcting the color to that of fluorescent lamps. You could use the mixed lighting and post-production methods described on pages 112–115, but it is best to get it right at the shoot.

The most common filters are blue, to match daylight. Full blue is –131 mireds; half-blue –68 mireds; and quarter-blue –49 mireds. These filters are available as heat-resistant gels (actually plastic film), glass, and dichroic. Dichroic filters are partial mirrors, reflecting red back to the lamp and passing blue; they are not always consistent, and ideally should be checked before use with a color-temperature meter.

Lamp position

Moving the position of the lamp in its reflector changes the spread of the beam. When it is as far back as possible, the beam is relatively narrow; moved forward, the lamp is not as enclosed, and so spreads more.

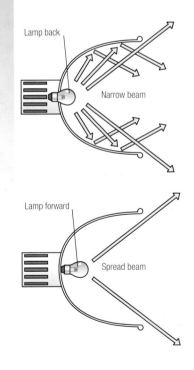

Lamp back

Narrow beam

Lamp forward

Spread beam

Reflector angle

Some tungsten lights in which the lamp position is fixed offer a lens-precise control of the beam spread with hinged reflector panels. These are the basic configurations of a Lee-Lowell Totalite.

Closed

Open

Filters

It is often more convenient to filter each lamp rather than to use a lens filter on the camera. Fittings vary, but usually avoid enclosing the lamp to prevent overheating. A universal fitting is an outrig frame, which attaches in front of the light. It is essential to use purpose-made nonflammable filter material with lamps.

▼ Filters

This range of filters, intended for use over light sources, is designed for raising and lowering color temperature, and for reducing levels from certain sources.

1/8 CTO converts 5500K to 4900K for very slight warming. Mired shift +20; 92% transmission.

1/4 CTO converts 5500K to 4500K, or 4000K to 3200K for slight correction or when daylight is warm. Mired shift +42; 81% transmission.

1/2 CTO converts 5500K daylight to 3800K, or 4500K to 3200K for partial correction or when daylight is fairly warm. Mired shift +81; 73% transmission.

85N3 combines the effects of the 85 and N3 filters. Mired shift +131; 33% transmission.

85N6 combines the effects of the 85 and N6 filters. Mired shift +131; 17% transmission.

N3, a neutral filter, reduces light level by 1 stop. 50% transmission.

N6, a neutral filter, reduces light level by 2 stops. 25% transmission.

85 used over windows or flash heads to convert 5500K to 3200K, the standard window correction when using type B film and photographic tungsten lamps. Mired shift +131; 58% transmission.

1/8 blue boosts 3200K to 3300K. Use as for 1/2 blue left. Mired shift −12; 81% transmission.

Full blue is a standard correction filter from tungsten (3200K) to daylight (5500K). It is commonly used over photographic tungsten lamps with daylight-balanced film. Mired shift −131; 36% transmission.

1/2 blue for partial conversion from 3200K to 4100K to compensate for voltage reduction or to boost domestic tungsten when used with photographic tungsten lamps. Mired shift −68; 52% transmission.

1/3 blue for partial conversion from 3200K to 3800K. Use as for 1/2 blue left. Mired shift −49; 64% transmission.

1/4 blue boosts 3200 K to 3500K. Use as for 1/2 blue left. Mired shift −30; 74% transmission.

Attachments and supports

Being able to position lights in exactly the right point in space is as important to effective lighting design as more obvious properties such as beam control and diffusion, particularly with regard to overhead positions. No matter how powerful or effective the lamp or flash unit, its usefulness should always be considered in proportion to how easily and securely it can be fixed or supported.

A few large, sophisticated lights are self-supporting—they are supplied with their own means of positioning—but most need additional help. The first, essential function of any such fixture is to hold a light, and whatever fittings it needs to control the quality, in the right position. It is pointless having a good lighting system and then needing to make compromises in the photograph just because you cannot obtain the lighting direction that you would like. Certain lighting angles are difficult, particularly with large diffuser fittings, but if this is what the photograph needs, you should try to find a practical way of providing support.

Apart from being able to aim the light in the right direction and from the right height, there are several other factors that you should consider before buying any supports. The first is that it should be safe and secure. The heavier and larger a light, the more important this factor is. The lamps themselves usually cause few problems and, if they sit on an appropriate size of conventional stand, they cause none at all.

Most lamps that are used in still photography are fitted either with a spigot or a socket; in either case these are $5/8$ inch (16mm) in diameter. The same is true of most stands. The spigots fit into the sockets, and double-ended separate spigots are available to convert sockets if necessary. Some very heavy tungsten lights, not normally used in still photography, have $1\frac{1}{8}$ inch (29mm) spigots, and some lighting systems use, inconveniently, individual proprietary methods of attachment.

Overbalancing problems are likely to occur when the stand or fixture used is too small or lightweight for the lamp; when a heavy fitting is attached to the lamp and shifts the center of gravity; and when lighting is suspended, tilted, or cantilevered out at an angle overhead. Test fixtures by shaking them gently and by applying pressure in different directions. For the sake of safety, wires, pins, clamps, and so on can be attached to the lamp, tying it in to a secure fixture (usually on the wall or on the ceiling), in case of the support failing in some way.

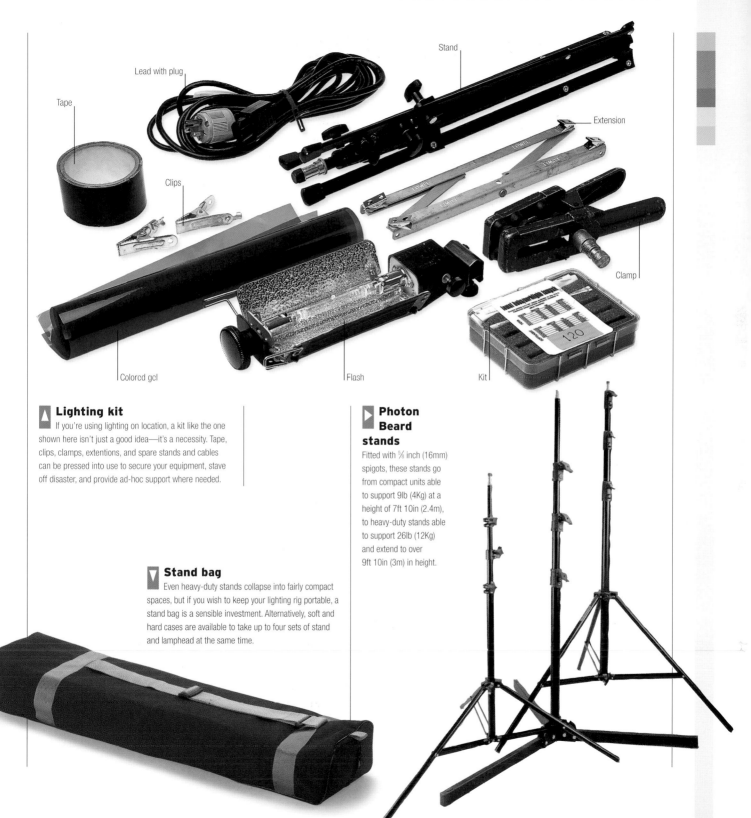

Tape

Lead with plug

Stand

Extension

Clips

Clamp

Colorcd gcl

Flash

Kit

Lighting kit

If you're using lighting on location, a kit like the one shown here isn't just a good idea—it's a necessity. Tape, clips, clamps, extentions, and spare stands and cables can be pressed into use to secure your equipment, stave off disaster, and provide ad-hoc support where needed.

Photon Beard stands

Fitted with ⅝ inch (16mm) spigots, these stands go from compact units able to support 9lb (4Kg) at a height of 7ft 10in (2.4m), to heavy-duty stands able to support 26lb (12Kg) and extend to over 9ft 10in (3m) in height.

Stand bag

Even heavy-duty stands collapse into fairly compact spaces, but if you wish to keep your lighting rig portable, a stand bag is a sensible investment. Alternatively, soft and hard cases are available to take up to four sets of stand and lamphead at the same time.

Controlling flare

Protecting the camera lens from any light that is not contributing to the image is a critical part of a studio setup, and greatly improves image quality.

In studio lighting it is normal to use a variety of lamps and fittings, and some are often only just out of view in an image. These are likely conditions for causing flare, particularly if you make late adjustments to the lighting and forget to check the effect carefully through the viewfinder. Flare often occurs at the edges and corners of the photograph, and you may not be fully aware of it until the image is enlarged.

Flare control principally involves shielding the lens from light. We can be a little more precise about this. Any light that reaches the lens and does not come from the picture area can cause flare, so the ideal solution is to mask down the view in front of the lens right to the edges of the image. The most sophisticated professional lens shades do just this; either by extending and retracting, or by having adjustable sides that can be moved in and out, they leave only the picture area exposed to view.

There are three places for shading the lens from flare. One, just mentioned, is on the lens itself, or just in front of it. Another is between the camera and the lights, using larger masks, or "flags," as they are known, made of black card or similar materials on stands. The third is on each lamp. Some lamps are available with barn doors—hinged flaps that cut off the main beam at the sides. Others can be fitted with a simple flag on an adjustable arm.

▼ Lens shades
The three most common types of lens shade are (left to right): the screw-on or bayonet-mounted shade made for a specific focal length; the adjustable bellows shade, which adapts to a variety of focal lengths; a simple black flag clamped in front of the lens.

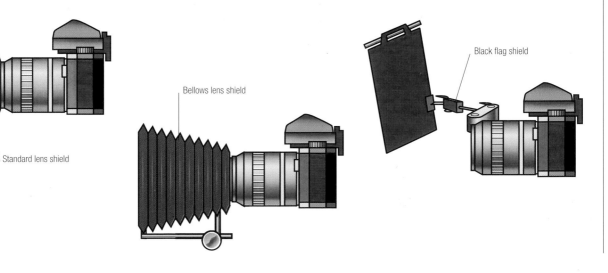

Standard lens shield

Bellows lens shield

Black flag shield

The most important flare control is to cut off the spill from a direct beam. A straightforward technique is to look at the lens from in front, and then to move whatever mask you are using until its shadow falls across the lens and just covers it. Any further control depends on the lighting; if there are strong reflections from walls or other bright surfaces, it is wise to go one step further. To do this, move the masks until they just appear through the viewfinder, and then move them back out of sight a fraction.

Finally, a special case of controlling flare in still-life photography is when you are shooting onto a bright surface, particularly when you are using a broad overhead light. The bright surface that surrounds the picture area will produce a kind of flare that is not immediately obvious, but that degrades the image nevertheless. The solution to this problem is to mask down the surface itself with black paper or card.

Background flare
Even a white background can degrade the image. Having set up the camera, mask down to the edges of the frame with black paper or cloth. Do this while looking through the camera viewfinder. The position of these black masks depends on the focal length of the lens (and so its angle of view).

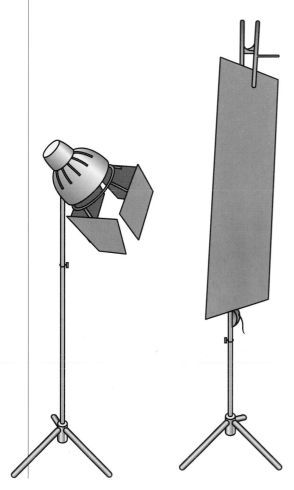

Light shades
The alternative to shading the lens is to shade the light sources. Although this is usually impractical on location, in a studio or small interior it is generally straightforward.

Diffusion

Softening the output of a lamp is the most basic procedure in lighting. It cuts hard shadows and makes the illumination more even.

You can diffuse a light by shining it through a translucent material; the important effect of this is to increase the area of the light source. Think of the naked lamp, whether flash or tungsten, as the raw source of light, small and intense. Unless there is a lens and a beam-focusing mechanism, the pattern of light will be intense in the middle, falling off rapidly toward the edges. The beam may also be uneven in shape, depending on the construction of the lamp and the built-in reflector. Check this for yourself by aiming the light directly at a white wall from fairly close, and then stand well back and look at the spread of the beam.

Placing a sheet of translucent material in front of the lamp makes this sheet—the diffuser—the source of light for all practical purposes. Try this out for yourself with a lamp on a stand, aimed horizontally. From in front, the light is intense and small; this is why the shadows that it casts are deep and hard-edged. Now take a rectangle of translucent acrylic of the type similar to that used for light boxes. Hold it in front of the lamp; if it is very close, or very large, you will see a bright center graduating outward to darker edges: this is exactly the same as when the lamp was aimed at a white wall. Move the sheet away from the lamp and toward you until it looks fairly evenly illuminated. This is efficient diffusion, and the source of light is now the acrylic sheet.

The area of the light is larger, and so the shadows it casts have soft edges and are less intense overall. One side-effect is that the intensity of the light is reduced, and this is more or less in proportion to the degree of diffusion. The greater the thickness of the diffusing material, the more light it absorbs. If the diffusion is increased by moving the light farther away, natural falloff will reduce the intensity.

Modeling effect
Although the lighting in this shot is highly directional, diffusing it weakens the shadow density, and softens the shadow edges, while at the same time reducing the highlights. On subjects with strong relief and pronounced detailing, as this marble putti in Washington's Library of Congress, it gives a better sense of form.

▼ Diffusion & shadow 3

And, as a close view shows, the shadow density varies considerably, from very weak close to the edge, to quite strong directly underneath. In fact, only a small central circle underneath the sphere is completely hidden from the diffused light.

▲ Diffusion & shadow 1

The essential difference between naked and diffused light is in the way each treats shadows. The shadow edge from an undiffused lamp is hard, because the source is tiny, almost a point. In addition, the density of the shadow is deep and uniform, not only on the underside of the object, but the cast shadow underneath on the surface.

▲ Diffusion & shadow 2

Placing a diffuser between the light and the object in effect makes the light source larger. Essentially, the diffusing surface becomes the light. Being larger, some of the illumination from it weakens the shadow edge and the shadow density.

◀ Extreme diffusion

The lighting for this arrangement of spices needed to be almost shadowless for clarity, while still retaining some highlights to distinguish individual seeds. The set-up was a large diffuser from a short distance, so that the area of the light was larger than the area of the subject. Additional shadow fill came from silvered reflectors on each side.

Varying the diffusion

The amount of diffusion depends on the translucency of the material, on its distance from the light, and on the size of the diffuser relative to the subject.

Three factors control the degree of diffusion, which means that there are three ways in which you can increase it or decrease it. The first is the thickness of the diffusing material (two separated sheets have the same effect as one single, thicker sheet). For any given distance between the light and the diffuser, the optimum thickness of the diffuser occurs when it absorbs any falloff from the center of the beam. In other words, the diffuser needs to be sufficiently thick to give the effect of a thoroughly even coverage, from corner to corner. If the diffuser is thinner, the light will appear brighter in the center and darker toward the corners—the area of the light will be, as a result, a little smaller. However, if the diffusing sheet already projects an even light, increasing its thickness will only lower the intensity—it will not create any more diffusion.

The second factor is the distance between the light and the diffuser. The greater this is, the wider the spread of the beam, and the less noticeable the falloff from center to edge. This; therefore, also increases the area of the diffused light, although as long as the illumination is even across the sheet, moving it farther from the light does nothing to help.

Turning now from the light source to the subject, the amount of diffusion in the light it receives depends on the third factor: size. The larger the area of light appears from the position of the subject, the greater its diffusing effect. Imagine yourself as the subject underneath a typical area light. If the rectangular area light is small or far away, it occupies only a small part of the "sky," and the shadows that it casts will be fairly hard-edged and deep. If it is replaced with a larger rectangle, or is brought closer, it fills more of your view. The light reaches you from a greater angle, and this weakens the shadows and softens their edges.

The important measurement is the relative apparent size, a combination of the size of subject, size of area light, and the distance between them. One way of combining these elements in one measurement is to take the angle of view from the subject to the light, making allowance for the size of the subject. As a general guide, as long as the light appears the same size as the subject or larger, it is diffuse.

▲ **A light tent**
The extreme of diffusion occurs when the light surrounds the object from all visible sides (the qualification of "visible" is important; light from opposite the camera contributes nothing). To achieve this, the diffusing sheet must be shaped to wrap around the subject. Compare this studio version with the natural diffusion from a completely overcast sky (*see pages 72–73*).

Larger diffused light

A large area light (relative to the size of the subject) gives good diffusion, measured as the angle of view from beneath the subject.

Larger subject

The same light as above with a larger subject has less diffusing effect (a more acute angle of view). Also, the working space is reduced, in this case impractically.

Smaller diffused light

A small area light from closer gives the same angle of view as above, and so the same diffusion. There may be practical problems, however, in sufficient working space between light and subject, and lens flare may be an issue.

Smaller subject

The same light with a smaller subject has a greater diffusing effect. As these four variations show, it's the relative size of light and subject that is the critical factor.

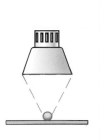

Variations on diffusion

Standard diffusion, 1, can be modified by: 2, using a thicker diffuser, which gives a more even area of light; 3 , moving the light farther away, for a similar effect; 4, using a larger sheet of diffusing material, which increases the area of the light source; and 5, moving the diffuser closer to the subject, to make the light source relatively larger.

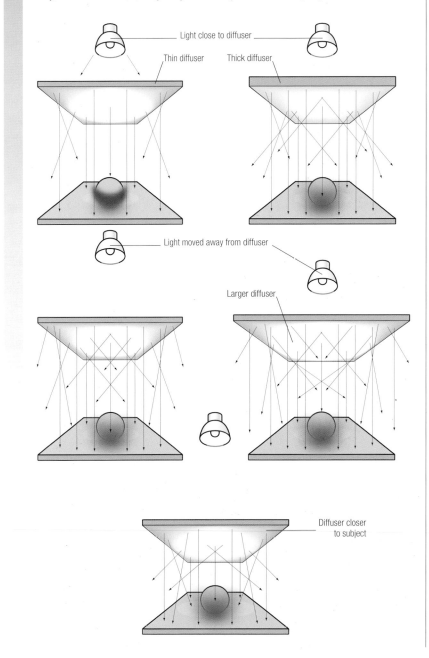

Diffusing materials

Any translucent material can be turned into a diffuser, and its thickness, composition, and texture will add subtle qualities to the final effect.

Diffusing materials have various qualities that are not always immediately noticeable. One is texture, apparent in fabrics, netting, and corrugated plastic. To some extent, this texture actually helps the diffusing effect by scrambling the light that passes through it, making the diffuser more efficient. However, if any part of the subject or setting is highly reflective—a polished surface, perhaps, smooth metal, or a liquid—there is always a possibility that the diffused light will itself appear as a reflection. If so, any texture in the diffusing screen will be visible, and this may spoil the image. Another quality is the shape of the diffuser. This also becomes important when its reflection can be seen, and even with non-reflective subjects. It may matter if you use the diffused light to cover only a part of the scene. The falloff from a diffused light is soft and gradual, but if you need it to occur precisely, following a line, the diffuser must have an appropriate shape. The simplest and least obtrusive shapes are rectangular and are the staple lighting for still-life work. Portraiture rarely needs this kind of precision and umbrellas are more usual.

Allied closely to the shape of the diffuser is control over the amount of spill from the sides. The space between the diffuser and the lamp lets direct light escape, and this will reflect off any bright surroundings, including the walls and ceiling of the room and equipment used close to the set. One basic method of limiting the spill is to shade the lamp with barn doors or flags, angled so as to limit the beam of light as much as possible to the diffuser. A more efficient method is to seal the gaps entirely, effectively enclosing the light into a soft box (also known as an area light or window light; these are very popular for still-life photography). There are several possible designs, all boxlike. Ideally, the interior of the fitting helps to control the beam so that

Testing for neutral color

Although it is normally safe to assume that the basic light source, if purpose-built for photography, is color-balanced, there is usually no guarantee that the diffusing material will not add a cast. In practice, most of the materials are neutral: if a material looks white to the eye, it will probably transmit the light without altering any of the wavelengths. Nevertheless, you should test the materials that you finally choose. Use one of the fixed white-balance settings, such as flash, not Auto, for this test.

If the diffusing screen makes any difference at all, it will be very small. To check in detail, use a neutral gray card. Take one shot with no diffusion, and then however many others are necessary to test the different screens that you have. Finally, adjust the white balance using the compensation controls (if available on your camera) or by using the Preset white balance.

the front translucent panel is evenly lit: most such fittings are shaped to act as reflectors and have reflective surfaces either in bright metal or white.

Enclosing a light like this is safe only if the heat output is low, and this is a good time to consider the relative merits of flash and tungsten for diffusion (*see pages 140-141*). Tungsten lamps, particularly the highly efficient tungsten-halogen variety, generate a great deal of heat, and the majority of diffusing materials, if not actually inflammable, can warp and discolor if placed close. Fittings that enclose create a buildup of heat, and cannot safely be used with tungsten lamps unless they have a built-in electric fan or ventilation. For choice of diffusion, flash has major advantages over tungsten.

▲ Clean texture

Highly reflective subjects, such as these drops of mercury, will reveal any texture in the diffusing material.

Diffusing materials

Opal tough frost: Like light tough frost but less dense.

Light tough frost: Lower density form of tough frost.

Tough frost: Medium diffuser, spreading the beam but keeping the center.

Tough white diffusion: Heat resistant, with similar properties to tracing paper.

Tough rolux: Dense dffuser which gives soft, almost shadowless light, useful for adding several lights into a single light area source.

Roscoscrim: Perforated material for reducing transmission by 25 percent through windows.

Light tough rolux: Like tough rolux, but less dense.

Tough silk: Slight diffusion, maintaining directional qualities of the light.

Tough spun: Slight diffusing, softening edges but maintaining the shape of the bearm. Light tough spun and Quarter tough spun also shown.

Corrugated diffusing plastic sheet.

Opalescent perspex.

Grid cloth: Reinforced diffusing material which can be sewn.

Light grid cloth: Lower density form of grid cloth.

Soft frost: Moderately dense, like tough frost, but giving more diffusion.

Hilite: Moderate diffusion with high transmission and no color termparature shift.

Reflection

Aiming a studio light away from the subject and toward a large bright surface is an easy, convenient way of diffusing the light, but in a small studio you need to be careful that this does not happen inadvertently.

Bouncing light off a bright surface is mainly an alternative to diffusion. Its effects are very similar, both in principle (it increases the area of the light) and in the way it softens shadows and lowers contrast. Although it is difficult to control bounced light as precisely as diffusion can be controlled, which means that bounced light is not as useful for still-life shooting, reflective lighting can be very easy and convenient. Suitable surfaces are commonly available, and photographic lamps can often be used naked, without any fittings at all. What reflection can do particularly well is to produce extremely diffuse lighting; so soft as to be almost shadowless. The value of this is when you simply want to increase the level in order to use a smaller aperture or shutter speed, without the appearance of introducing another light.

In the basic arrangement for lighting by reflection, the light is aimed directly away from the subject toward a white surface. There are several potential problems for controlling the light in such a setup. The silhouette of the lamp and stand appears in view; the beam is not even and does not have precise limits; and changing the direction of the lighting would involve moving both the light and the reflecting surface separately (which obviously is not possible if you are using a wall as a reflecting surface). On the positive side, lighting by reflection can be a space-saver, because, by bouncing, the light path is effectively being folded in half.

To maintain full control over reflections, as in very precise still-life shooting, some professional photographers paint their studio walls and ceiling either black, for no unwanted reflections at all, or a neutral mid-gray. The smaller the studio space is, the more this matters. In a large studio, the space beyond the set may be sufficient to kill any stray reflections.

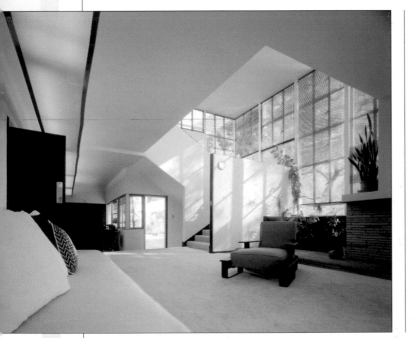

Window reflection
One use of reflected lighting is to boost the light level in an interior when daylight is visible through a window. Here, a 1000-watt halogen lamp, filtered with a full blue gel (*see page 134*) was sited behind the camera, pointing up and back, to give a shadowless increase in lighting.

Corner | Rear wall

Ceiling | Ceiling in front

Side wall

◀ ▽ Positioning a fill light

There are several variations possible on basic bounce-lighting techniques. Experiment with the ones illustrated here. Moving the light closer to the wall, corner, or ceiling increases the brightness, even though it means moving the light away from the subject, but it also concentrates the reflection.

△ △ Frontal reflectors

In still-life and close-object photography, a main difffused light above is one of the standrad techniques, used here for a highly reflective gold bar. This leaves the forward-facing surfaces at risk of underexposure, easily solved by small reflectors placed just out of frame under the camera.

Reflector materials

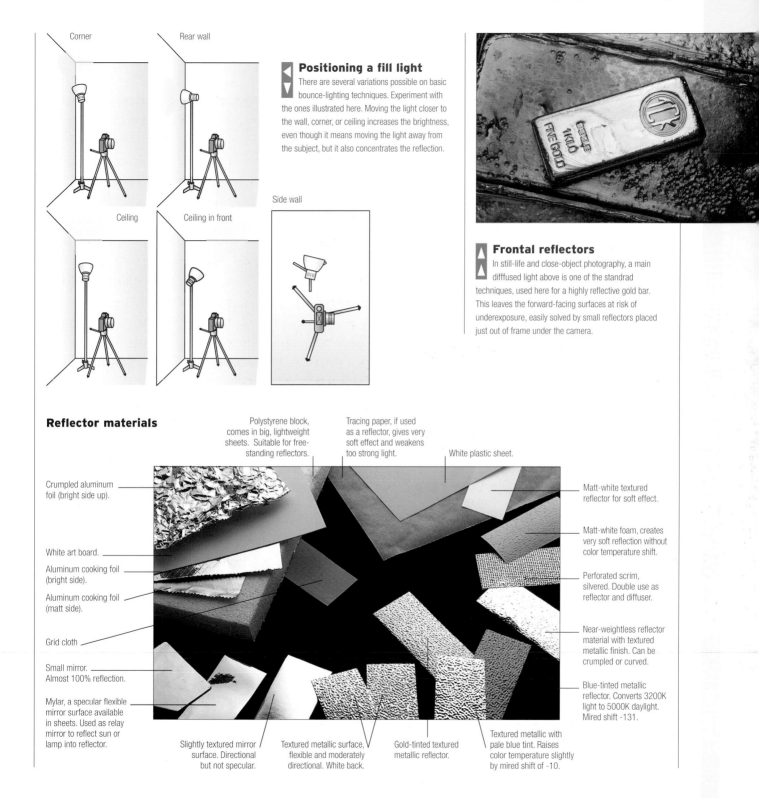

Polystyrene block, comes in big, lightweight sheets. Suitable for free-standing reflectors.

Tracing paper, if used as a reflector, gives very soft effect and weakens too strong light.

White plastic sheet.

Crumpled aluminum foil (bright side up).

White art board.

Aluminum cooking foil (bright side).

Aluminum cooking foil (matt side).

Grid cloth

Small mirror. Almost 100% reflection.

Mylar, a specular flexible mirror surface available in sheets. Used as relay mirror to reflect sun or lamp into reflector.

Matt-white textured reflector for soft effect.

Matt-white foam, creates very soft reflection without color temperature shift.

Perforated scrim, silvered. Double use as reflector and diffuser.

Near-weightless reflector material with textured metallic finish. Can be crumpled or curved.

Blue-tinted metallic reflector. Converts 3200K light to 5000K daylight. Mired shift -131.

Slightly textured mirror surface. Directional but not specular.

Textured metallic surface, flexible and moderately directional. White back.

Gold-tinted textured metallic reflector.

Textured metallic with pale blue tint. Raises color temperature slightly by mired shift of -10.

Concentration

In contrast to diffusion and reflection, concentrating light is a precision technique to limit its spread and confine it to an exact area, often for dramatic, high-contrast effects.

Although diffusion increases the area of a light source, concentration is not its complete opposite. A diffuser spreads the illumination, but then so can a naked lamp if unshielded and used without a reflector fitting behind. Concentration is concerned with the area of light that falls on the subject—its size, shape, and the sharpness of its edges.

Light can be concentrated at various points in the beam: by shaping the reflector behind the lamp; by using a focussing lens; by flagging the light at the sides; and by masking it close to the subject (including placing a black card with an aperture cut into it in front of the light). The most efficient method by far is to use a lens, and this is how focussing spots and luminaires work. The lens makes it possible to produce a sharp-edged circle of light on the subject, and its size (and even its shape) can be varied. Although focussing spot fittings are available for flash units, they are mechanically simpler for tungsten lighting, as the focus can be judged by sight. The modeling lamp in a flash unit is usually in a slightly different position and has a different shape from the flash tube, and therefore focussing the modeling lamp will not always have exactly the same effect on the flash.

This is extreme concentration, which is not needed very often in most studio photography (although it is very useful for rim-lighting effects, such as highlighting hair in a beauty or portrait shot). The basic kind of light

Strong concentration
Snoots and lenses give tight beams. This Bowens Esprit universal spot attachment focusses the light from the flash unit. Using a lens attachment on a lamp makes it easier to judge the final effect.

Universal spot attachment

ProSpot

Snoot
The tapering barrel of the snoot concentrates the light into a tighter beam. The result is not as intense as the beam from a lens attachment.

Photon BeardSnoot

Snoot grid
The honeycone grid adds a further level of control over the quality and intensity of the concentrated light.

concentration is created by shaping the reflector of the lighting unit itself. This has a different kind of focussing effect. Except in those lamps (usually tungsten) that contain a control for moving the relative positions of the lamp and reflector to alter the beam, all the standard reflector fittings are designed to give what is considered to be a normal beam: in the region of 60 to 90 degrees. This is quite concentrated, but additional reflector fittings narrow the beam still further. The most effective reflector design is parabolic.

Apart from using reflection to concentrate the beam, other methods work subtractively—by cutting off light at the edges, leaving just the central part—with the result that the beam loses some intensity. Fittings on the light include a snoot, or cone, and various types of mask such as flags and barn doors. Other masks, such as black card, can be used closer to the subject; the closer they are placed, the better defined are the edges of the illumination.

▲ High concentration

For the strongest spot-lighting effect, concentrated lights like those at the bottom of the opposite page generally need to be positioned at some distance from the subject. To isolate the desk and typewriter (*above*) from the surroundings, a 400-joule flash fitted with a snoot was suspended from a boom close to the ceiling.

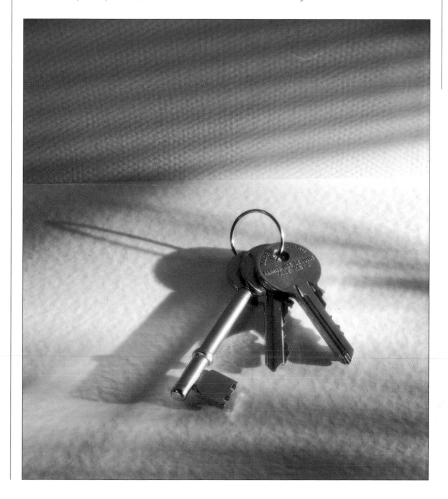

◀ Focusing spot

A lensed spot used at a raking angle from the right and slightly behind gives a clear and controllable shadow of a bunch of keys, cast on a textured paper surface. These shadows, and others cast by objects strategically placed between the light and the keys, have the effect of adding interest to a very basic shot.

Modeling form

Use a variety of side lighting, modulated by diffusion to soften the shadows, to convey the maximum impression of the roundness and depth of objects.

▲ High-contrast modeling
One technique, suitable with fine detail, as in this close-up of the curved side of a wooden Shaker box with swallow-tail grooves, is to use a hard raking light—in this instance, bright sunlight unmodulated by any reflector opposite. The effect can be graphic and powerful.

One of the most basic challenges in all two-dimensional arts, including painting and photography, is to convey the three-dimensional solidity and volume of a real object. This depends very heavily on a kind of illusion, because form is essentially the representation of volume and substance. By comparison, shape is fairly straightforward because it is a more purely graphic quality, and comes across easily even in a silhouette limited to two tones. As a plastic quality, however, form needs a lighting technique that stresses roundness and depth—full realism, in effect. Lighting for form inevitably results in representational photography.

In principle, then, the techniques for showing form involve using the modulation of light and shade. This means that the lighting should be directional, throwing distinct shadows, and from an angle that gives a reasonable balance between the light and the shade. Strongly frontal or back lighting does not work particularly well. In the first, the shadows cover only a small visible part of the object, while in the second, the lit areas appear very small. Any version of side lighting, however, gives a modulation that is more equally divided.

There are two things involved in using light and shade in this way. One is the darkening of the surface from one side of the object to the other; this alone gives an impression of bulk and volume. The second is the shadow edge itself. Its shape and position as seen from the camera give more detailed information about the relief. Both of these qualities can be altered in three ways: by the direction of the lighting; the strength of the contrast; and the degree of diffusion. In addition, much depends on the object itself, and the best way to appreciate this is to take a simple, rounded object, such as a pot, and with one light only, take a series of images with slight variations, as shown in the sequence opposite.

Light slightly to front

Moderate diffusion, no reflector

Full diffusion, no reflector

Full diffusion, with reflector

Light slightly behind

Moderate diffusion, no reflector

Full diffusion, no reflector

Full diffusion, with reflector

▲ Simple volume

Small changes to the lighting make delicate but appreciable differences to the way the form of an object is recorded. A pre-Columbian pot was used for this project; in the left three pictures the lighting is slightly frontal, and in the right three pictures the lighting is slightly behind.

▶ Soft modulation

The highly reflective surface of this white cowrie shell, and the deep shadows inside, call for a more delicate means of modeling—a heavily diffused overhead light plus frontal reflectors. The gentle curves of the shell are revealed without the distraction of hard highlights.

Varying the Light

Three basic variations will affect the modeling. Lighting controls modeling, which is essentially the treatment of form and relief. The three lighting variables are the angle, diffusion, and shadow fill, as these diagrams illustrate.

Lighting angle

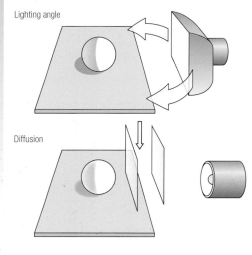

Diffusion

Contrast

Revealing transparency

Of all the possible physical qualities of an object, transparency needs the greatest care, depending heavily on various forms of back lighting. Translucency is a muted, more opaque quality.

A transparent object essentially refracts its background. As a result, it is the lighting of the background that needs major attention, and the most common method of photographing something transparent is to make the light the background. Effectively, this involves some kind of backlighting in most situations. Although this is hardly a rule, there is rarely any other way of showing the transparent qualities of an object while also keeping the image simple and legible. If the transparent object has to feature strongly in a photograph, then it needs some variety of lighting to show through it. The most obvious and cleanest technique is transillumination. For this, the light source should be

Blackening the edges

Plain backlighting gives a clean rendition and brings out the delicate color of the liquid, but the edges of the glass need to be defined, otherwise they would simply merge with the background. The standard solution is to place pieces of black card out of frame.

broad and fairly even—a light box placed beneath the subject is ideal.

Objects that are completely transparent, such as clear glass bottles and jars, pose an additional problem: that of making a clear, legible picture. The edges of an object define its shape, but in a transparent material there is always a danger that these edges become lost to view. To get the maximum definition of outline in, say, a bottle or glass, mask down the area of the backlight as much as possible. The masking must be behind the transparent object. There are two methods for this: to use black cards or flags; or simply to move the light source farther back.

▲ Highlight gradation

To emphasize the faceted base and sculptural modeling of this crystal lion, black card was used at the edges, although the light was not completely diffused, but graded by placing it close to the diffusing background sheet.

◀ Backlit color

A perfect and uncomplicated subject for backlighting—cricket lollipops. The colors come out beautifully, while the silhouettes of the crickets encased within are perfectly readable. Imperfections in the candy give texture.

Exposure calculation

Calculating the exposure for back-lighting needs care, but is not particularly difficult. With a broad back-lighting source, treat the background as a highlight. This gives you two fairly simple methods of measuring the exposure. One is to take a direct meter reading, either with the TTL meter in the camera or a handheld meter pointed directly toward the object with its reflected light fitting. The reading you get will then be between 2 and 2½ stops brighter than average, so simply add that amount of exposure to the camera setting. The second method is to use a handheld meter with its reflected-light dome, with the sensor pointing directly toward the backlight. This will give an exposure setting that will be within ½ stop of a good exposure.

Emphasizing texture

Texture is a quality of structure and surface rather than of tone or color, and so appeals principally to the sense of touch—and the way that we imagine it would feel.

Texture is the tactile quality of a surface; of the skin of an object rather than its body. It is mainly, but not entirely, a matter of local relief, with rough and smooth as the two extremes. This in turn depends on how closely you look at a surface: from a few inches, a block of concrete appears, and feels, rough, but seen as part of a building from a distance, it looks completely smooth. A woman's skin may seem smooth enough in a head-and-shoulders portrait, but if you shoot a close-up of just the lips, you will find that an enlargement will show all kinds of imperfections.

This range of coarseness of texture has upper and lower limits. The upper limit is when the relief is so strong that it affects the actual shape of the object; it is no longer a quality of the surface, but of the thing itself. The lower limit is the point at which the surface appears smooth. From the examples mentioned above, you can see that this is entirely relative. At some degree of magnification, the smoothest surfaces have a strong texture. It is also subjective; there is no objective measurement that you can apply.

Strictly speaking, even a mirror-like finish is a texture of sorts. Experience of natural lighting shows what the most effective studio conditions should be. Go back for a moment to side lighting on pages 48–49, and in particular to the photograph of the paper lantern. As a general rule, a naked lamp at a

▼ Acute lighting angle
The polished surface of this partially carved wood made a diffused area light essential (to avoid harsh specular highlights). This gives a pleasant edge to the gourdlike carved shape, and accentuates the natural grain. Nevertheless, the key to this lighting is the placement of the area light, at a sharp angle from above.

Experimenting with texture

As a basic exercise in discovering texture, take a surface with a distinct, hard-edged relief, such as a rough brick or the crust of a loaf. Experiment with the two basic lighting variables, angle and diffusion. Vary each, and from the results decide which gives the strongest and clearest impression of texture. Hard light from a small naked source and an acute angle to a flat surface will always make textures seem strong, but this may be at the expense of legibility.

Then collect the following surfaces, or those of them that you can find easily, and produce the best textural photograph that you can for each: silk, leather, glazed ceramic, fur, a metal grille, gravel. Note the different adjustments that you need to make to the position of the light, its diffusion, and the position of the surface.

raking angle to the surface is the classic treatment to give strong texture.

However, the actual angle should depend very much on the coarseness of the texture. If the relief is strong and deep, a very shallow angle may lose detail unnecessarily. One technique you should consider is to add a reflector opposite the light to lighten the shadows and preserve this detail. If you move a lamp to an increasingly acute angle, there comes a point at which most of the surface falls into shadow, and the texture suddenly becomes lost (this, of course, is what happens at sunset). Strong texture can accommodate some degree of diffusion. Texture may not be the only quality that you want to bring out in the subject, and the best lighting may be that which only just reveals the essential texture and no more.

Finally, some surfaces may combine two or more layers of different texture. A wrinkled fabric, for instance, has the texture of the weave and the texture of the wrinkles. The lighting angle that suits one may be less satisfactory for the other.

Adding folds to textiles

Textiles, and in particular silk, with its shot appearance, can easily be given character and volume simply by pushing them into folds. A moderately angled light will then bring out the varying texture.

Raking light

For this selection of Indian breads, a low sun was ideal, with an aluminium-foil reflector oppsite to lighten the shadows. The rough, matt, appetizing texture of the breads is brought out more strongly by undiffused light.

Toward the window

Shooting at an oblique angle toward a large light source is one way of giving a broad highlight to rounded surfaces, in this case an old Shaker milk bucket. The light source is a north-facing window.

Glossary

aperture The opening behind the camera lens through which light passes on its way to the CCD.

artifact A flaw in a digital image.

backlighting The result of shooting with a light source, natural or artificial, behind the subject to create a silhouette or rim-lighting effect.

bit (binary digit) The smallest data unit of binary computing, being a single 1 or 0.

bit depth The number of bits of color data for each pixel in a digital image. A photographic-quality image needs eight bits for each of the red, green, and blue channels, making for a bit depth of 24.

bracketing A method of ensuring a correctly exposed photograph by taking three shots; one with the supposed correct exposure, one slightly underexposed, and one slightly overexposed.

brightness The level of light intensity. One of the three dimensions of color in the HSB color system. See also Hue and Saturation

byte Eight bits. The basic unit of desktop computing. 1,024 bytes equals one kilobyte (KB), 1,024 kilobytes equals one megabyte (MB), and 1,024 megabytes equals one gigabyte (GB).

calibration The process of adjusting a device, such as a monitor, so that it works consistently with others, such as scanners or printers.

CCD (Charge-Coupled Device) A tiny photocell used to convert light into an electronic signal. Used in densely packed arrays, CCDs are the recording medium in most digital cameras.

channel Part of an image as stored in the computer; similar to a layer. Commonly, a color image will have a channel allocated to each primary color (e.g. RGB) and sometimes one or more for a mask or other effects.

CMOS (Complementary Metal-Oxide Semiconductor) An alternative sensor technology to the CCD, CMOS chips are used in ultra-high-resolution cameras from Canon and Kodak.

color temperature A way of describing the color differences in light, measured in Kelvins and using a scale that ranges from dull red (1,900K), through orange, to yellow, white, and blue (10,000K).

compression Technique for reducing the amount of space that a file occupies, by removing redundant data.

contrast The range of tones across an image, from bright highlights to dark shadows.

cropping The process of removing unwanted areas of an image, leaving behind the most significant elements.

depth of field The distance in front of and behind the point of focus in a photograph, in which the scene remains in acceptable sharp focus.

diffusion The scattering of light by a material, resulting in a softening of the light and of any shadows cast. Diffusion occurs in nature through mist and cloud cover, and can also be simulated using diffusion sheets and soft-boxes.

edge lighting Light that hits the subject from behind and slightly to one side, creating flare or a bright "rim lighting" effect around the edges of the subject.

feathering In image-editing, the fading of the edge of an image or selection.

file format The method of writing and storing information (such as an image) in digital form. Formats commonly used for photographs include TIFF, BMP, and JPEG.

fill-in flash A technique that uses the on-camera flash or an external flash in combination with natural or ambient light to reveal detail in the scene and reduce shadows.

filter (1) A thin sheet of transparent material placed over a camera lens or light source to modify the quality or color of the light passing through. (2) A feature in an image-editing application that alters or transforms selected pixels for some kind of visual effect.

focal length The distance between the optical center of a lens and its point of focus when the lens is focused on infinity.

focal range The range over which a camera or lens is able to focus on a subject (for example, 0.5m to Infinity).

focus The optical state where the light rays converge on the film or CCD to produce the sharpest possible image.

fringe In image-editing, an unwanted border effect to a selection, where the pixels combine some of the colors inside the selection and some from the background.

frontal light Light that hits the subject from behind the camera, creating bright, high-contrast images, but with flat shadows and less relief.

f-stop The calibration of the aperture size of a photographic lens.

gradation The smooth blending of one tone or color into another, or from transparent to colored in a tint. A graduated lens filter, for instance, might be dark on one side, fading to clear on the other.

grayscale An image made up of a sequential series of 256 gray tones, covering the entire gamut between black and white.

haze The scattering of light by particles in the atmosphere, usually caused by fine dust, high humidity, or pollution. Haze makes a scene paler with distance, and softens the hard edges of sunlight.

histogram A map of the distribution of tones in an image, arranged as a graph.

The horizontal axis goes from the darkest tones to the lightest, while the vertical axis shows the number of pixels in that range.

hot-shoe An accessory fitting found on most digital and film SLR cameras and some high-end compact models, normally used to control an external flash unit.

HSB (Hue, Saturation, Brightness) The three dimensions of color, and the standard color model used to adjust color in many image-editing applications.

hue The pure color defined by position on the color spectrum; what is generally meant by "color" in lay terms.

ISO An international standard rating for film speed, with the film getting faster as the rating increases. ISO 400 film is twice as fast as ISO 200, and will produce a correct exposure with less light and/or a shorter exposure. However, higher-speed film tends to produce more grain in the exposure, too.

lasso In image-editing, a tool used to draw an outline around an area of an image for the purposes of selection.

layer In image-editing, one level of an image file, separate from the rest, allowing different elements to be edited separately.

light tent A tent-like structure, varying in size and material, used to diffuse light over a wider area for close-up shots.

luminosity The brightness of a color, independent of the hue or saturation.

macro A mode offered by some lenses and cameras that enables the lens or camera to focus in extreme close-up.

mask In image-editing, a grayscale template that hides part of an image. One of the most important tools in editing an image, it is used to limit changes to a particular area or protect part of an image from alteration.

megapixel A rating of resolution for a digital camera, directly related to the number of pixels forming or output by the CMOS or CCD sensor. The higher the megapixel rating, the higher the resolution of images created by the camera.

midtone The parts of an image that are approximately average in tone, falling midway between the highlights and shadows.

monobloc An all-in-one flash unit with the controls and power supply built-in. Monoblocs can be synchronized together to create more elaborate lighting setups.

noise Random pattern of small spots on a digital image that are generally unwanted, caused by nonimage-forming electrical signals.

pixel (PICture ELement) The smallest units of a digital image, pixels are the square screen dots that make up a bitmapped picture. Each pixel carries a specific tone and color.

plug-in In image-editing, software produced by a third party and intended to supplement a program's features or performance.

ppi (pixels-per-inch) A measure of resolution for a bitmapped image.

reflector An object or material used to bounce available light or studio lighting onto the subject, often softening and dispersing the light for a more attractive end result.

resampling Changing the resolution of an image either by removing pixels (lowering resolution) or adding them by interpolation (increasing resolution).

resolution The level of detail in a digial image, measured in pixels (e.g. 1,024 by 768 pixels), lines-per-inch (on a monitor) or dots-per-inch (in a half-tone image, e.g. 1,200 dpi).

RGB (Red, Green, Blue) The primary colors of the additive model, used in monitors and image-editing programs.

saturation The purity of a color, going from the lightest tint to the deepest, most saturated tone.

selection In image-editing, a part of an on-screen image that is chosen and defined by a border in preparation for manipulation or movement.

shutter The device inside a conventional camera that controls the length of time during which the film is exposed to light. Many digital cameras don't have a shutter, but the term is still used as shorthand to describe the electronic mechanism that controls the length of exposure for the CCD.

shutter speed The time the shutter (or electronic switch) leaves the CCD or film open to light during an exposure.

SLR (Single Lens Reflex) A camera that transmits the same image via a mirror to the film and viewfinder, ensuring that you get exactly what you see in terms of focus and composition.

snoot A tapered barrel attached to a lamp in order to concentrate the light emitted into a spotlight.

soft-box A studio lighting accessory consisting of a flexible box that attaches to a light source at one end and has an adjustable diffusion screen at the other, softening the light and any shadows cast by the subject.

spot meter A specialized light meter, or function of the camera light meter, that takes an exposure reading for a precise area of a scene.

telephoto A photographic lens with a long focal length that enables distant objects to be enlarged. The drawbacks include a limited depth of field and angle of view.

TTL (Through The Lens) Describes metering systems that use the light passing through the lens to evaluate exposure details.

white balance A digital camera control used to balance exposure and color settings for artificial lighting types.

zoom A camera lens with an adjustable focal length, giving, in effect, a range of lenses in one. Drawbacks include a smaller maximum aperture and increased distortion over a prime lens (one with a fixed focal length).

Index

Acknowledgments

The Author would like to thank the following for all their assistance in the creation of this title:
Filmplus Ltd, Nikon UK, REALVIZ, and nikMultimedia

Useful Addresses

Adobe (Photoshop, Illustrator)
www.adobe.com

Agfa www.agfa.com

Alien Skin (Photoshop Plug-ins)
www.alienskin.com

Apple Computer www.apple.com

Corel (Photo-Paint, Draw, Linux)
www.corel.com

Digital camera information
www.dpreview.com

Epson www.epson.com

Extensis www.extensis.com

Formac www.formac.com

Fractal www.fractal.com

Fujifilm www.fujifilm.com

Hasselblad www.hasselblad.se

Hewlett-Packard www.hp.com

Iomega www.iomega.com

Kingston (memory) www.kingston.com

Kodak www.kodak.com

LaCie www.lacie.com

Lexmark www.lexmark.com

Linotype www.linotype.org

Luminos (paper and processes)
www.luminos.com

Macromedia (Director)
www.macromedia.com

Microsoft www.microsoft.com

Minolta www.minolta.com
www.minoltausa.com

Nikon www.nikon.com

Nixvue www.nixvue.com

Olympus
www.olympusamerica.com

Paintshop Pro www.jasc.com

Pantone www.pantone.com

Photographic information site
www.ephotozine.com

Photoshop tutorial sites
www.planetphotoshop.com
www.ultimate-photoshop.com

Polaroid www.polaroid.com

Qimage Pro
www.ddisoftware.com/qimage/

Ricoh www.ricoh-europe.com

Samsung www.samsung.com

Sanyo www.sanyo.co.jp

Shutterfly (Digital Prints via the web)
www.shutterfly.com

Sony www.sony.com

Sun Microsystems www.sun.com

Symantec www.symantec.com

Umax www.umax.com

Wacom (graphics tablets)
www.wacom.com